THE MUSHROOM BOOK

THE MUSHROOM BOOK

Recipes for Earthly Delights

MICHAEL MᶜLAUGHLIN

Illustrations by
Dorothy Reinhardt

CHRONICLE BOOKS

San Francisco

Library of Congress Cataloging-in-Publication Data:

McLaughlin, Michael.
 The mushroom book : recipes for earthly delights / by Michael
 McLaughlin : illustrations by Dorothy Reinhardt.
 p. cm.
 Includes index.
 ISBN 0-8118-0383-X (hc)
 1. Cookery (Mushrooms) I. Title.
 TX804.M38 1994
 641.6'58—dc20 93-31693
 CIP

Printed in Hong Kong.

Distributed in Canada by Raincoast Books,
112 East Third Ave., Vancouver, B.C. V5T 1C8

10 9 8 7 6 5 4 3 2 1

Chronicle Books
275 Fifth Street
San Francisco, CA 94103

For Susan Lescher,

who asked if I wanted to write about mushrooms

"If I can't have too many truffles, I'll do without truffles."

—COLETTE

Also written or cowritten by Michael McLaughlin

The Silver Palate Cookbook

The Manhattan Chili Co. Southwest American Cookbook

The New American Kitchen

The Back of the Box Gourmet

The El Paso Chile Company's Texas Border Cookbook

Fifty-Two Meat Loaves

Cooking for the Weekend

More Back of the Box Gourmet

The El Paso Chile Company's Burning Desires

TABLE OF CONTENTS

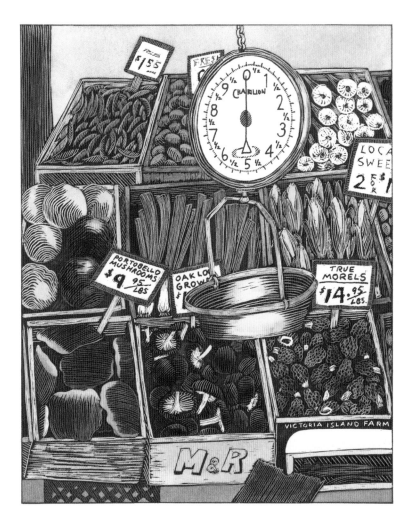

INTRODUCTION

✛　　✛　　✛

There are mushrooms among us. On restaurant tables, in specialty-food shops, and in the produce section of your neighborhood supermarket (courtesy of the grocery division of the mushroom soup giant, the Campbell Company, as well as a host of other growers and distributors), cultivated—formerly wild—exotic mushrooms are springing up in this country in ever greater numbers.

America has always been abundantly rich in wild fungi, but twenty years ago cooking them was primarily confined to the home cook–amateur mycologist and a few dedicated restaurant chefs (usually with European roots or training) in erratic alliance with the rare commercial forager. A change for the better came with the recent and welcome good food boom, during which few ingredients were left unexplored and American diners abandoned the bland and the safe for the lusty and the vivid. These mini-revolutions sort themselves out, usually for the better, and while the excitement over the kiwifruit seems to have quieted, mushroom mania has, if anything, increased.

Almost from the first bite, chefs and adventurous home cooks wanted a year-round supply of something more interesting than the ordinary white mushroom and something more reliable than elusive wild fungi. Growers, using centuries-old methods along with newly developed techniques and modern equipment, over-whelmingly answered the call. Cremini (also known as porto-bellos), shiitakes, and enoki and oyster mushrooms are now

widely available, success is predicted for three or four other varieties, and a host of lesser cultivated exotics are in limited production or can be grown from home mushroom kits. Compared to the three quarters of a billion tons of white mushrooms produced annually in the United States, exotic mushrooms (4.4 million tons during the last year for which figures are available) are small potatoes, but the dollar totals are impressive and production is expected to continue to rise.

Commercial foraging is booming as well. Indeed, competition in the Pacific Northwest, a fungi hotbed, became so intense lawmakers there were forced to propose licensing and other foraging regulations, simply to maintain order in the woods. While cultivated species are selected, at least in part, *because* they can be cultivated, wild mushrooms are chosen for no other reason than that they are delicious, and can now also be had from a growing number of specialty shops and mail-order sources.

Mycologists insist that mushrooms are not mysterious, but then publish voluminous manuals filled with lurid photos of bizarrely shaped and colored fungi, spore print exotica, warnings of toxicity, and worse (a favorite of mine describes the flavor of one mushroom as a cross between "Red Hots and dirty socks"; who tastes these things?). Even without such dubious help, it doesn't take several pounds of fungi field guide to give a shopper wandering through the produce section of the A&P a bad case of the doubts: Those sanitary little plastic containers of cultivated shiitakes from Campbell and others surely aren't harmful, *but what do I do with them?*

This book, in its modest way, is the answer. Relying mainly on the most widely found cultivated exotic mushrooms, supplemented occasionally by those truly wild fungi that are considered

culinarily indispensable, I have attempted to illustrate the considerable possibilities by starring mushrooms in forty distinctive recipes. Short notebook descriptions of the mushrooms scattered throughout the book will help shoppers sort out one variety from another; reliable dried mushrooms are used extensively; and mail-order sources and a list of recommended mushroom books will aid those who want to take things further.

Read and cook from this little mushroom book, and then the only mystery will be why you didn't start enjoying these delicious and fascinating fungi sooner!

<center>✢ ✢ ✢</center>

CHOOSING, STORING, AND COOKING EXOTIC MUSHROOMS

While some few mushrooms have unique buying, storing, and cooking requirements, which I have noted in their profiles, the following advice applies to the majority.

Wild or cultivated, mushrooms should be moist and plump, neither dry and shriveled nor wet and slimy, and without soft, discolored spots. Cultivated varieties are cleaner, more uniform, and usually in better condition; foraged mushrooms can vary wildly and are clearly more of an adventure.

Only cultivated mushrooms should be eaten raw. The best mushrooms for this will be those that are the most crisp; select specimens with tightly closed caps, which means their internal moisture is intact. Mushrooms with opened heads and visible gills will have suffered some moisture loss, softening their texture

and making them less than ideal for eating raw but concentrating their flavors, thus rendering them perfect for cooking. (At this point, in fact, even the normally pallid cultivated white mushroom begins to take on some real character.) There should be an odor of clean, fresh, damp earth; rotting mushrooms commonly have a strong, ammoniated smell. Mushrooms chosen from bulk displays will give the shopper more choice over both general conditions and specific concerns, such as size similarities.

Even robust mushrooms quickly lose their unique scent and taste, and most should be consumed within a day or two of purchase for best results. Remove the mushrooms from any sealed wrapper; those left airtight in plastic quickly become slippery and inedible (one exception is cultivated enoki, which should stay sealed in the original plastic until use). Leave those mushrooms with root clumps attached intact until preparation time. Lay the mushrooms in a single layer in a shallow, paper towel–lined dish or tray. Mushrooms that seem very moist can be covered with a clean, dry towel; those that seem dry can be draped with dampened (not wet) cheesecloth or a towel.

Fine-tuning mushroom storage is an ongoing process. One restaurant chef, who regularly receives just-picked mushrooms from the wild, believes a brief, unwrapped, refrigerated drying period produces a kind of skin even on fragile mushrooms, which actually helps retain moisture and flavor. Taking another tack, a grower of clean, firm shiitakes supplies a linen bag that keeps the mushrooms in good condition for several weeks (although the flavor diminishes somewhat). Tissuelike trompettes de la mort, which already seem half-dried, can be refrigerated in a paper bag for months, actually continuing to dry out without loss of flavor.

Refrigerate all fresh mushrooms until using. In case of over-abundance or a change in plans, mushrooms can be briefly sautéed in butter or oil and then frozen for a month or two with very good results. Experts disagree over whether uncooked mushrooms can be successfully frozen.

Trim mushroom stem ends just before using. Wipe the mushrooms with a dampened towel or clean with a mushroom brush that is not so stiff it damages the mushroom. Quickly wash only those mushrooms that absolutely require it (they soak up moisture as if they are a sponge, and then disgorge it when heated, diluting their juices and the dish in which they are being used) and pat thoroughly dry.

High heat dissipates the subtle flavor of mushrooms. Most mushrooms are best when sautéed—they love butter, but excellent olive oil also works well—at a medium temperature until some of the juices just begin to exude (salt speeds this) and then simmered with added liquid—stock, wine, cream. In some dishes the softened mushrooms are used with their rendered juices; in others, where texture and appearance count or where the excess liquid is undesirable, the heat is raised and the liquid evaporates and concentrates. In still other dishes, the mushrooms cook until they tenderly vanish into the savory whole.

Mushrooms have a natural affinity for certain flavors and seasonings. In addition to cream and butter, they are highly compatible with onions, garlic, leeks, shallots, almost all herbs but particularly marjoram, ginger, soy, smoked pork products, mustard, Madeira and sherry wines, olives, anchovies, eggs, potatoes, rice and other grains, sweet red peppers (especially good with shiitakes)—well, you begin to get the idea.

A NOTE ON SUBSTITUTIONS

No sensible forager would head to the woods looking, make or break, for a single kind of mushroom. Nature in general and mushrooms in particular are just not that predictable, and keeping an open mind is crucial if disappointment is to be avoided. Shopping for exotics—cultivated or foraged—requires a similar flexibility. Fortunately, with few exceptions, mushroom varieties are interchangeable in most recipes. Distinctive types like fruity, crunchy enoki mushrooms or the unique black truffle obviously can't be replaced by more typical cremini or shiitakes without altering and possibly ruining a recipe, but, in general, similarly solid and meaty mushrooms can be mixed or matched with good results.

The following recipes call for specific mushrooms or combinations of mushrooms that I found most successful during testing; those recipes specifying cremini, shiitakes, and oyster mushrooms, in particular, can be prepared using even cultivated white mushrooms, with only a modest loss of flavor and no change in texture.

HOW THEY DO THAT

Mushroom growth in nature is random and perilous; the commercial grower's job is to remove the mushroom of choice from such a competitive environment and then reproduce the positive conditions necessary for it to thrive. One leading exponent of mushroom cultivation calls it "the best combination of a passionate Art and a rapidly emerging Science," which is not to imply a shallow or recent history. Mushrooms have been cultivated for centuries, and worldwide it is estimated that over twenty-five hundred varieties are successfully farmed.

All mushrooms are fungi (but not all fungi are mushrooms) and about 80 percent grow symbiotically with trees, gathering nutrients for the tree and receiving sugar in return; the rest grow on rotting logs, compost, or manure. Spores are the reproductive cells—"seeds," if you like—of fungi; scattered by winds, wildlife, and other methods, they eventually grow into an enormously long and threadlike underground network called a mycelium. The mycelium is the actual fungus plant; the portion we harvest and eat is the fruit, which is the term growers actually use.

From spores, or, more reliably, through cloning, a desirable mushroom strain is isolated and then sprouted on a sterile medium (frequently millet or another grain) into a mycelial mass, which in turn is encouraged to multiply into a larger mass called spawn. The growing medium, officially the "bulk substrate," chosen to replicate the mushroom's natural habitat (such as the rotting oak logs shiitakes prefer) is then inoculated with small amounts of the spawn, typically in the form of a plug inserted into it.

The environment can be outdoors or in (at least one Pennsylvania grower of white mushrooms is located in an abandoned coal mine). Fruiting can begin in weeks, months, or years; can be fast or slow; can last for a season or for much longer. Mushrooms are finicky. The grower's job until harvest time is maintaining the temperature, humidity, and light (or lack thereof) under which the mushroom strain in question will flourish, a tricky set of variables that needs constant monitoring.

Within this simple framework are myriad possibilities, fine-tuned through experience, trial and error, or luck into a greater or lesser degree of success, the results of which eventually show up in your produce store, intriguingly, invitingly for sale.

<p style="text-align:center">✢ ✢ ✢</p>

FRESH VERSUS DRIED

Like many other foods that come briefly but abundantly into season, mushrooms are preserved in various ways, the most common and most successful method being the oldest—drying. For wild-mushroom gatherers, long strings of dried mushrooms represent the edible rewards of both luck and hard work; the rest of us will have to resort to expending cold cash, although the eating will be similarly fine.

Available in everything from tiny prepacked bags stapled onto display cards to enormous gourmet-shop glass jars of loose mushrooms sold by the ounce, dried morels, porcini or cèpes, chanterelles, trompettes de la mort, shiitakes, wood ears, and, sometimes, other varieties can be found year around by cooks

who are in the mushroom mood. Are dried mushrooms inferior to fresh? Are un-dried tomatoes preferable to sun-dried? Are grapes "better" than raisins?

Purchased dried mushrooms are expensive, reflecting their loss of substantial moisture, but an ounce or even less, depending on the type of mushroom, will generously flavor a dish for six diners. In the shop or in your pantry, the mushrooms will remain usable for many months, even years, if they stay free from insect infestation.

Do not buy mushrooms that you cannot see (some of those packets on cards have clear windows and some do not) or those that, in the words of one cooking expert, have dust that is weblike or moving on its own. Store the mushrooms in a cool, dry place (your freezer if you live in a humid climate) and try to use them within six months or so, although I have enjoyed good results from mushrooms much older.

Reconstitute dried mushrooms before using by soaking them until plump and tender in hot wine, water, stock, or another liquid. That liquid contains plenty of flavor—frequently also plenty of grit—and should be added to the dish at hand or refrigerated or frozen for another time.

As for the grit, remember that your dried mushrooms most likely were gathered in the wild, and proper handling has so far precluded any serious contact with water. Rinse them vigorously in a strainer under cold running water before reconstituting them, and rinse them again afterward if they seem to need it. Even the most scrupulous cook is unlikely to get all dried mushrooms totally clean. Like tuna sandwiches eaten at the beach, a certain amount of crunch is sooner or later a part of the experience. Let the soaking liquid settle, then pour off and reserve the

clear portion and discard the sandy residue. The truly frugal can strain the last of the soaking liquid through paper towels or a coffee filter, capturing every woodsy drop.

As for which is preferable, fresh or dried, as with raisins and dried tomatoes, the process transforms the mushrooms into what is really another food. The flavors are enhanced and concentrated, remaining more intense and even slightly smoky after reconstitution, and the texture will always be somewhat chewy. Dried mushrooms are neither better nor worse than fresh, just gloriously different and equally delicious.

<div align="center">✛ ✛ ✛</div>

FATAL ATTRACTIONS

Of the many thousands of kinds of wild mushrooms, experts say only about thirty are *very* poisonous, with symptoms ranging from mild nausea to paralysis and death. Like their edible cousins, these fatal fungi bear colorful (though scarier) names such as yellow stainer, death cap, Satan's bolete, and destroying angel.

Since mushrooms do not grow with name tags attached, and since some culinary varieties are almost indistinguishable from their lethal lookalikes, it is imperative that you neither eat nor even gather a mushroom from the wild without being certain what it is.

Guidebooks alone—even good ones—are not the solution, since they may be incomplete for your area. Supplement what you find in them with advice from a local mycological expert to get the most out of your woodland bounty.

Many areas boast wild mushroom hunting groups that, should you wish to begin learning to gather your own, are the best source for local knowledge and invaluable instruction. The ready availability of cultivated exotic mushrooms in the supermarket and the rise in the number of knowledgeable commercial foragers may have eliminated the need for the personal search, but like bird watching or any other outdoor hobby, mushroom hunting is an inspiring way to get in touch with nature, and worth engaging in for its own sake, even if you never collect a single specimen. For more information, and the address of a local chapter, contact The North American Mycological Society, 3556 Oakwood, Ann Arbor, Michigan 48104.

APPETIZERS & SALADS

CORN-BATTERED MORELS
with Watercress Dipping Sauce

BAKED SAUSAGE-AND-OLIVE-STUFFED MUSHROOMS

MUSHROOM TAPENADE

GRILLED PORTOBELLO "STEAKS"
with Green Sauce

GORGONZOLA RAGOUT OF MUSHROOMS
with Polenta

BRANDIED PÂTÉ FORESTIÈRE

RAW MUSHROOM, FENNEL, AND PROVOLONE SALAD
with Toasted Walnuts

WILTED GREEN SALAD
with Warm Mushroom Dressing

CORN-BATTERED MORELS
with Watercress Dipping Sauce

Such an informal, rustic method of cooking and enjoying the magnificent morel must surely come from someplace with an abundant and affordable supply, and indeed, deep-frying is common in the Midwest, where morels thrive. The tart, green watercress dip is a nice idea, but purists may prefer to stick with a squirt of fresh lemon juice.

¾ cup unbleached all-purpose flour
⅓ cup yellow cornmeal
¾ teaspoon salt
½ teaspoon sugar
½ teaspoon freshly ground black pepper
2 eggs
1 cup milk
About 6 cups corn oil, for frying
¾ pound fresh morels
Coarse (kosher) salt
Watercress Dipping Sauce (recipe follows)
Lemon wedges (optional)

In a medium bowl stir together the flour, cornmeal, salt, sugar, and pepper. In a small bowl whisk the eggs; whisk in the milk. Whisk the egg mixture into the flour mixture, stirring until smooth. Let the batter stand for 20 minutes.

Position a rack in the middle of the oven and preheat to 250 degrees F. Cover a baking sheet with several layers of paper towels.

In a deep-fryer or in a deep, heavy pan fitted with a thermometer and set over medium heat, warm the oil (it should fill the deep-fryer or pan no more than halfway) to between 360 and 375 degrees F.

Stir 6 to 8 morels into the batter, then lift them in batches from the batter with a fork, letting the excess drip back into the bowl. Lower the morels carefully into the hot oil and fry them, turning once or twice, until crisp and golden, about 4 minutes. With a slotted spoon transfer the morels to the prepared sheet pan and keep warm in the oven. Repeat with the remaining morels.

Just before serving, sprinkle the morels lightly with coarse salt and transfer to a napkin-lined basket. Serve immediately, accompanied with the watercress sauce and with lemon wedges, if desired.

SERVES 6

WATERCRESS DIPPING SAUCE

1 bunch watercress, coarse stems trimmed
2 green onions, green tops included, roughly chopped
1 cup sour cream
½ teaspoon salt
½ teaspoon fresh lemon juice
½ teaspoon hot-pepper sauce

Have ready a medium bowl filled with iced water. Fill a saucepan with water and bring it to a boil over high heat.

Stir the watercress into the boiling water, wait 10 seconds, and drain immediately. Transfer the watercress to the iced water and cool completely. Drain well and, with your hands, squeeze out as much liquid as possible from the watercress.

In a food processor combine the watercress and green onions and chop. Add the sour cream, salt, lemon juice, and hot-pepper sauce and process until as smooth as possible. Adjust the seasoning, transfer to a bowl, and serve.

Or the dipping sauce can be prepared 1 day ahead, covered, and refrigerated. Return it to room temperature and adjust the seasoning before using.

MAKES ABOUT 2 CUPS

MOREL

ALSO: MORILLE (FRANCE),
GUHCHI (INDIA)

Pale yellowish tan to dark gray with honeycombed conical shape and hollow stem and core unique among mushrooms. Sizes range from pencil skinny and an inch long to five-inch jumbos. Fresh morels may or may not be differentiated as yellow, white, or black. Dried specimens also vary in color but are rarely labeled as to variety.

Fresh: Nutty and mushroomy but very delicate. For many the texture is the message, the waffled cap perfectly suited to absorbing sauces. Reconstituted dried: More intensely mushroomlike than fresh, with a haunting, smoky quality (some are dried over open fires). The increased flavor, as well as the availability and convenience of pantry storage, make dried morels almost more useful than fresh ones.

Season: Spring throughout moister northern United States; also (finally!) cultivated successfully and selectively throughout the year on sterile material plus wood ash (wild morels seem to be more abundant in seasons following a forest fire).

Rinse quickly and briskly if necessary, cutting very gritty specimens in half first, and pat dry immediately. Caps may harbor insects. Cultivated specimens are usually grit-free.

Morels eaten raw can cause stomach upsets. A few people are similarly sensitive only to black morels, even when cooked, or to any variety of cooked morels eaten in combination with alcohol.

BAKED SAUSAGE-AND-
OLIVE-STUFFED MUSHROOMS

To prepare this hearty first course, fragrant with sweet sausage, garlic, and fennel seed, and served in a puddle of tomato sauce, look for the oversized cultivated white mushrooms marketed as "stuffers," or pick through a bin of loose cremini, selecting the largest you can find.

2 tablespoons unsalted butter

2 tablespoons plus 1 teaspoon unbleached all-purpose flour

1½ cups milk

¼ teaspoon salt

¼ teaspoon freshly ground black pepper

Pinch of freshly grated nutmeg

24 large (2½ inches in diameter) fresh stuffing mushrooms

1 tablespoon olive oil, plus oil for the baking dish

¾ pound (4 medium links) Italian-style sweet sausage,
* removed from the casings and crumbled*

½ cup finely chopped yellow onions

2 garlic cloves, chopped

¼ teaspoon fennel seeds

¼ teaspoon crushed red pepper

¼ pound (about 18) brine-cured black Greek Kalamata olives,
* pitted and chopped*

½ cup finely chopped fresh flat-leaf parsley

⅓ cup freshly grated Parmesan cheese

3 cups Fresh Tomato Sauce (page 117) or other good-quality
* meatless tomato sauce, heated to simmering*

To make a thick béchamel sauce, in a small, heavy saucepan over low heat, melt the butter. Whisk in the flour and cook, stirring often, for 4 minutes; do not brown. Remove from the heat and whisk in the milk. Stir in the salt, black pepper, and nutmeg and set the pan over medium-low heat. Bring to a simmer, cover partially, and cook, stirring occasionally, until very thick, about 15 minutes. Transfer the béchamel to a medium bowl and cool to room temperature.

Remove the mushroom stems and finely chop enough to yield

CULTIVATED WHITE MUSHROOM

ALSO: BUTTON MUSHROOM, CHAMPIGNON DE PARIS, AGARICUS BRUNNESCENS

Pale ivory, crisp, and delicately flavored (market specimens are immature; fully grown mushrooms are somewhat tastier), but nonetheless the most widely cultivated mushroom in the world.

The technique for farming *Agaricus brunnescens* (formerly *A. bisporus*) from the common field mushroom was developed by the French in the seventeenth century—possibly even before the Japanese began cultivating the shiitake. Originally farmed in abandoned quarry caves near Paris (hence champignon de Paris); arrived widely on the market as the old style of medieval cookery gave way to modern haute cuisine and usage rose accordingly.

Cultivated in Pennsylvania for over one hundred years, the snow white commercial variety now most widely available (in button, medium, and "stuffer" sizes) was developed in 1926.

½ cup; reserve the remainder for another use. Pull away the soft gill edges of the mushroom caps to create the largest possible cavity for stuffing.

In a medium skillet over moderate heat, warm 1 tablespoon of the olive oil. Add the crumbled sausage and cook, stirring often, until lightly browned, about 12 minutes. With a slotted spoon transfer the sausage to paper towels to drain.

Set the skillet (do not clean it) over medium heat and stir the chopped mushroom stems, onions, garlic, fennel seeds, and red pepper into the sausage drippings. Cook uncovered, stirring occasionally, until the vegetables are tender and lightly colored, about 8 minutes. With a slotted spoon remove the vegetables from the skillet and stir them into the béchamel. Stir the sausage, black olives, and parsley into the béchamel. The recipe can be prepared to this point 1 day in advance. Cover by pressing plastic wrap onto the surface of the filling and refrigerate. Bring to room temperature before proceeding.

Position a rack in the upper third of the oven and preheat to 450 degrees F. Lightly oil a large, shallow baking dish. Spoon the stuffing into the mushroom caps, mounding it and arranging the filled mushrooms in the prepared dish as you go. Sprinkle the filled mushrooms with the cheese. Bake until lightly browned and sizzling, 12 to 15 minutes. Remove from the oven and let the mushrooms stand in the dish on a rack for 5 minutes.

With a bulb baster or a spoon, remove the mushroom juices from the baking dish and stir them into the simmering tomato sauce. Divide the sauce among 8 small plates. Arrange 3 mushrooms atop the sauce on each plate and serve immediately.

SERVES 8

MUSHROOM TAPENADE

The rough Provençal caper-and-black-olive purée called tapenade is a dark and potent thing, and it has become a kind of culinary symbol for the region. Unlike some symbols, it's also very good to eat, stuffed into hard-cooked eggs, dolloped onto sliced tomatoes or a hot baked potato, or just scooped up with a hunk of crusty bread and washed down with a glass of cool white wine. This mushroom variation is slightly less intense than the traditional version but is otherwise no less habit-forming. Prepare it at least one day ahead to allow the flavors to develop.

7 tablespoons olive oil
½ pound fresh cremini, quartered
½ pound fresh shiitakes, quartered
2 tablespoons minced mixed fresh herbs, such as thyme,
 rosemary, oregano, and marjoram
4 garlic cloves, chopped
¾ teaspoon salt
½ teaspoon freshly ground black pepper
⅓ cup dry red wine
½ pound (about 36) brine-cured black Greek
 Kalamata olives, pitted
2 tablespoons small (nonpareil) capers, drained
5 oil-packed anchovy fillets, drained
2½ tablespoons fresh lemon juice

In a large, nonreactive skillet over medium-high heat, warm 3 tablespoons of the olive oil. Add the mushrooms, herbs, garlic,

salt, and pepper and cook, tossing and stirring often, until the mushrooms begin to render their juices, about 5 minutes. Stir in the wine, lower the heat slightly, and cook uncovered, stirring occasionally, until the liquid has evaporated and the mushrooms are tender, about 7 minutes. Cool to room temperature.

In a food processor combine the mushroom mixture, olives, capers, anchovies, and lemon juice and process until finely chopped. With the motor running, gradually add the remaining 4 tablespoons olive oil; the mixture will thicken. Do not over-process; some texture should remain.

Transfer the tapenade to a container, cover tightly, and refrigerate for at least 24 hours; the tapenade can be prepared up to 3 days ahead. Let it come to room temperature before serving.

Makes 2½ cups, serving 6 or more
depending upon usage

GRILLED PORTOBELLO "STEAKS"
with Green Sauce

In the fall in Italy, when porcini are at their peak, purists grill the plate-sized slabs, glossed with a little excellent olive oil and seasoned with nothing more than salt and pepper. Such handsome porcino specimens seldom reach this country, and when they do their sticker price can take the edge off of anyone's appetite. Hence I offer this more affordable adaptation, using oversized mature cremini, or portobellos. Many Italian cooking experts wholeheartedly endorse this substitution, and although the flavor of cremini is more subtle than that of porcini, when grilled over a smoky wood fire and napped with a fragrant green sauce, they do make a remarkably satisfying starter.

1 cup loosely packed fresh flat-leaf parsley leaves
1 cup loosely packed fresh basil leaves
1½ tablespoons balsamic vinegar
1 egg yolk
3 oil-packed anchovy fillets, drained
1 tablespoon small (nonpareil) capers, drained
1 garlic clove, chopped
¼ teaspoon salt
¼ teaspoon freshly ground black pepper
About ¾ cup olive oil
1 cup wood smoking chips, preferably mesquite
16 large (5 inches in diameter) fresh portobellos, stems removed
 and reserved for another use

In a food processor combine the parsley, basil, vinegar, egg yolk, anchovies, capers, garlic, salt, and pepper. Process until the mixture is as smooth as possible. With the motor running, gradually add ½ cup of the olive oil; the sauce will thicken. Adjust the seasoning. The sauce can be prepared up to 3 days ahead, covered, and refrigerated; return it to room temperature before use.

Soak the wood chips in water to cover generously for 1 hour. Light a charcoal fire and let it burn down until the coals are evenly white, or preheat a gas grill (high heat).

Brush the portobello caps generously on both sides with the remaining olive oil. Drain the wood chips. Scatter them over the coals or the firestones, set the grill rack about 6 inches above

CREMINI

ALSO: CRIMINI, ROMAN, ITALIAN BROWN, PRATAIOLI, COMMON BROWN

A variation of the cultivated white mushroom, the common brown was once the most widely sold cultivated mushroom in the United States. Now enjoying a resurgence due to the clever marketing of the mushroom under a variety of Italianate names and a general increase of interest in brown and earthy (as opposed to whitely insipid) ingredients.

Flavor and Texture: Both seem to be slightly enhanced versions (tastier, firmer) of those of the common white mushroom (although one expert claims that blindfolded no one could tell the difference).

Frequently sold with its root clump and clinging substrate intact, to preserve flavor and freshness. Remove just before preparation.

the heat, and cover the grill. When the chips are smoking, arrange the mushrooms on the grill, spacing them well apart. Cover and grill, turning the caps once at the approximate halfway point, until the edges have darkened slightly and the mushrooms are tender and heated through but not dried out, 3 to 4 minutes total.

Arrange 2 mushroom caps on each of 8 plates. Spoon a generous dollop of the sauce over each pair of mushroom caps and serve immediately.

SERVES 8

PORTOBELLO

ALSO: PORTABELLA

A fully mature cremino, with a dramatically large, wide, flat, fully opened cap and visible gills. Like the cremino, this mushroom's commercial name is a marketing ploy that has succeeded wildly.

Portobellos, with the loss of moisture that results from being sold fully opened, have a slight but obvious increase in flavor over regular cremini.

Portobellos are best stemmed (save for stocks) but otherwise left whole, the caps grilled or sautéed, and topped or sauced. They make a fine addition to or a main ingredient for a meatless Italian-type hero sandwich.

GORGONZOLA RAGOUT
OF MUSHROOMS
with Polenta

In this plated first course, mild (*dolcelatte*) Italian Gorgonzola cheese melts into and mingles with the juices of chunky, sautéed mushrooms to create a creamy but emphatic sauce. Choose strongly flavored mushroom varieties (shiitakes, porcini, cremini—the more the tastier), and serve the ragout spooned around crisply sautéed disks of polenta.

4 tablespoons (½ stick) unsalted butter
⅓ cup minced shallots
2½ pounds assorted fresh mushrooms, quartered or thickly sliced
1 teaspoon salt
½ cup homemade chicken stock or canned chicken broth
6 ounces Gorgonzola dolcelatte or other creamy mild blue cheese,
 at room temperature, crumbled
½ teaspoon freshly ground black pepper
Crisp Polenta Rounds (recipe follows)
¼ cup finely chopped fresh flat-leaf parsley

In a large skillet over medium-low heat, melt the butter. When it foams add the shallots and cook without browning, stirring once or twice, for 3 minutes. Add the mushrooms and salt and cook uncovered, stirring and tossing, until the mushrooms begin to render their juices, about 5 minutes. Add the chicken stock and simmer, stirring occasionally, until the liquid in the skillet is reduced by half, about 5 minutes. Stir in the Gorgonzola and

pepper, immediately remove from the heat, cover, and let stand, stirring once or twice, until the cheese just melts and blends with the mushroom juices.

Arrange a polenta round on each of 8 plates. Spoon the mushrooms and their juices around the polenta rounds. Sprinkle the mushrooms with the parsley and serve immediately.

SERVES 8

CRISP POLENTA ROUNDS

Olive oil for the pan, plus 3 tablespoons olive oil
1 cup yellow cornmeal, preferably stone-ground
4 cups water
1½ teaspoon salt
1 teaspoon freshly ground black pepper
2 bay leaves

Lightly brush an 8-inch round, straight-sided pan with oil. Measure the cornmeal into a medium, heavy saucepan. Slowly whisk in the water. Set the pan over medium heat and stir in the salt, pepper, and bay leaves. Bring to a simmer, stirring often. Reduce the heat to medium-low, cover partially, and cook, stirring often, until the polenta is very thick, about 25 minutes.

Remove and discard the bay leaves. Pour the hot polenta into the prepared pan and spread it evenly to the edges. Cool to room temperature, then cover and refrigerate until very firm, at least 5 hours.

With a 2-inch cutter, form 8 polenta rounds (reserve the remaining odd-shaped pieces for another use). In a large, heavy skillet over medium-high heat, warm the remaining 3 tablespoons oil. Add the polenta rounds and cook, turning once or twice, until heated through, crisp, and golden, about 5 minutes total. Drain briefly on paper towels; serve while hot.

MAKES 8 ROUNDS

BRANDIED PÂTÉ FORESTIÈRE

Although smooth in texture, this easy pâté (really a soft spread) has strong, direct flavors that make it the perfect starter for a classic bistro-style meal (roast chicken, potato gratin, crème caramel). Present it in a cool, heavy crock, pass country-style bread, and drink a subtle pink wine, such as Rosé d'Anjou.

⅓ cup (about ⅓ ounce) dried porcini
1 cup chicken stock or reduced-sodium canned chicken broth
3 tablespoons Calvados (unsweetened French apple brandy)
 or Cognac
4 tablespoons (½ stick) unsalted butter
⅓ cup minced shallots
3 garlic cloves, minced
1 ½ tablespoons minced fresh thyme
1 pound chicken livers, trimmed and patted dry
¾ teaspoon salt
½ teaspoon freshly ground black pepper
2 tablespoons heavy cream

In a strainer under cold running water, thoroughly rinse the porcini. In a small saucepan bring the chicken stock to a boil. In a small, heatproof bowl, combine the porcini and boiling stock, cover, and let stand, stirring once or twice, until cool.

With a slotted spoon remove the porcini from the soaking liquid; mince the mushrooms and set aside. Let the liquid settle for 5 minutes, then pour off and reserve the clear portion; discard the sandy residue.

In a small saucepan combine the soaking liquid and Calvados. Set over medium heat, bring to a brisk simmer, and cook, stirring once or twice, until reduced to ¼ cup, about 7 minutes. Remove from the heat and cool to room temperature.

Meanwhile, in a large skillet over low heat, melt the butter. Add the shallots, garlic, and thyme; cover and cook, stirring once or twice, for 8 minutes. Add the chicken livers, salt, and pepper, raise the heat to medium-high, and cook, tossing and stirring, until the livers are firm but still slightly pink, about 6 minutes. Remove from the heat and cool slightly.

In a food processor combine the contents of the skillet, the minced mushrooms, the reduced soaking liquid, and the cream and process until smooth, stopping once to scrape down the sides of the work bowl. Transfer the mixture to a 2-cup crock and smooth the top. Cover and refrigerate for 24 hours to allow the flavors to develop. Let the pâté stand at room temperature for 15 minutes before serving.

MAKES ABOUT 2 CUPS; SERVES 6 TO 8

RAW MUSHROOM, FENNEL, AND PROVOLONE SALAD
with Toasted Walnuts

This lively salad is full of little shocks of texture and flavor, making it a perfect appetite-awakening starter. Serve it on its own or combine it on an arranged antipasto platter with marinated olives, paper-thin prosciutto, and rounds of toasted bread rubbed with garlic and brushed with good olive oil.

½ cup (about 2 ounces) walnuts
1 pound fresh cremini, thinly sliced
1 small (½ pound) fennel bulb, trimmed
 and cut into thin vertical slices
2 tablespoons fresh lemon juice
¼ teaspoon salt
2 tablespoons olive oil
2 tablespoons walnut oil
2 tablespoons finely chopped fennel fronds
2 tablespoons finely chopped fresh flat-leaf parsley
Freshly ground black pepper
About ¼ pound provolone cheese, in one piece

Position a rack in the upper third of the oven and preheat to 375 degrees F. Spread the walnuts in a single layer in a shallow metal pan, like a cake tin, and toast them, stirring once or twice, until they are crisp, lightly browned, and fragrant, about 10 minutes. Remove from the pan and cool to room temperature.

In a large bowl toss together the mushrooms and sliced fennel. In a medium bowl whisk together the lemon juice and salt. Gradually whisk in the olive and walnut oils; the dressing will thicken. Pour the dressing over the mushroom mixture and let stand, stirring once or twice, for 10 minutes.

Add the chopped fennel fronds, parsley, and cooled walnuts, season generously with freshly ground pepper, and toss thoroughly. Spoon the salad onto 4 plates. Holding the piece of provolone over the salads and using a swivel-bladed vegetable peeler, shave long curls of cheese generously over the salads (you will not use all the cheese). Serve immediately.

SERVES 4

WILTED GREEN SALAD
with Warm Mushroom Dressing

Few first courses are as vividly fragrant as a warm salad—they always get the diner's hungry attention. Add deeply flavored mushrooms, garlic, and good balsamic vinegar to the mix and the result is absolutely rousing. For the best effect, both visual and culinary, use three or more varieties of both greens and mushrooms, selecting those of varying texture and taste.

6 tablespoons olive oil
⅓ cup sliced shallots
2 garlic cloves, minced
⅓ pound fresh shiitakes, thickly sliced
¼ pound fresh chanterelles, thickly sliced
¼ pound fresh cremini, thickly sliced
¾ teaspoon salt
10 cups mixed sturdy salad greens such as arugula, spinach,
radicchio, and frisée, in bite-sized pieces
3 tablespoons balsamic vinegar
Freshly ground black pepper

In a large skillet over medium heat, warm 3 tablespoons of the olive oil. Add the shallots and garlic, cover, and cook, stirring once or twice, for 4 minutes. Add all the mushrooms, season with ½ teaspoon of the salt, re-cover, and cook, stirring once or twice, until the mushrooms just begin to render their juices, about 4 minutes. Uncover the skillet, raise the heat to high, and cook, tossing and stirring the mushrooms, until the juices have evaporated, about 1 minute.

Meanwhile, in a very large bowl, toss the salad greens with the remaining 3 tablespoons olive oil and remaining ¼ teaspoon salt. Remove the skillet from the heat, stir in the vinegar, and immediately pour the mushroom mixture over the greens. Toss well, season generously with pepper, and toss again.

Divide the salad among 4 plates and spoon any juices left in the bowl evenly over the salads. Serve immediately.

SERVES 4

CHANTERELLE

G old or apricot and shaped like a meaty petunia blossom or trumpet, the golden chanterelle is the best-known member of a large clan of similarly colored and shaped mushrooms. Size varies from bite-sized specimens to five- or six-inch giants.

Widely admired in Europe as one of the two or three finest culinary mushrooms and increasingly celebrated in the United States; grows wild only, mainly in the Pacific Northwest and northern California, from early summer through early winter.

Fresh: Mildly mushroomy, nutty, peppery, cinnamony, apricotlike, or reminiscent of shellfish. Dried: Very expensive, the gold reduced to a pleasant tan. When reconstituted, their texture is chewy, their flavor elusive and delicate.

Clean carefully, removing grit with a soft brush, slicing vertically (to preserve the shape) or even rinsing briefly in water if necessary. Pair with chicken, eggs, or seafood; sauté gently and glaze them with meat juices (not even stock) and their own exuded liquid.

Also look for both blue and white chanterelles, black trumpets, and yellow-footed chanterelles.

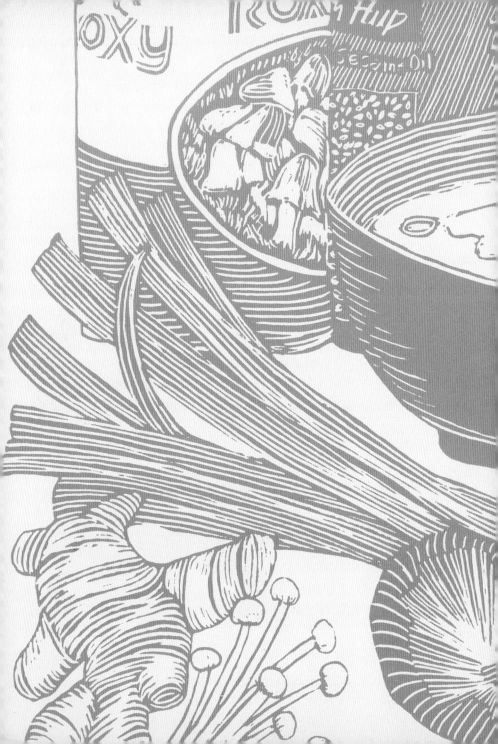

SOUPS & SANDWICHES

GINGERED SOUP OF ASIAN MUSHROOMS
with Garlic Custards

DRIED MUSHROOM, BARLEY, AND LENTIL SOUP

STEAK SANDWICHES
with Mushroom - Red Wine Sauce

GRILLED TURKEY-SHIITAKE BURGERS
with Plum Mayonnaise

TOASTED CRAB, CHEESE,
AND MUSHROOM SANDWICHES

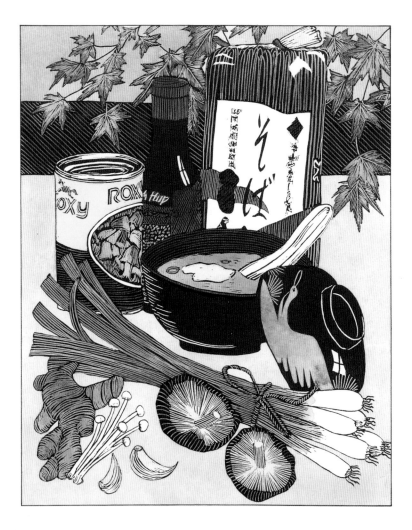

GINGERED SOUP
OF ASIAN MUSHROOMS
with Garlic Custards

This is a brothy sort of soup, thickly afloat with a trio of mushrooms and other ingredients, all of varying sizes, flavors, and textures. A light main-course soup, it is a slurpy and satisfying delight to eat. Creamy, garlicky custards are rich stand-ins for the tofu one might expect to find; the substitution is a fine and tasty surprise.

½ ounce (about 5 large) dried Japanese shiitakes
9 cups lightly salted homemade or canned chicken broth
1 tablespoon grated fresh ginger
2 garlic cloves, passed through a press
4 ounces dried soba (Japanese buckwheat noodles)
1 can (15 ounces) straw mushrooms, drained
1 large bunch watercress, coarse stems trimmed
1 package (3½ ounces) fresh enoki mushrooms, trimmed
2 green onions, green tops included, sliced
½ teaspoon Asian sesame oil (from roasted seeds)
Garlic Custards (recipe follows)

In a strainer under cold running water, rinse the shiitakes. In a large soup pot over medium heat, bring the chicken broth to a boil. Add the shiitakes, remove the pot from the heat, cover, and let stand for 30 minutes. With a slotted spoon transfer the shiitakes to a cutting board and remove and discard the stems; thickly slice the caps.

Set the soup pot over medium heat. Stir in the ginger, garlic, and the sliced shiitakes; bring to a simmer. Add the soba, return to a simmer, cover, and cook, stirring occasionally, until the noodles are almost tender, about 4 minutes. Add the straw mushrooms and cook for 1 minute. Stir in the watercress, enoki mushrooms, green onions, and sesame oil, remove from the heat, cover, and let stand for 1 minute.

Ladle the soup into 6 wide, deep bowls. Run the tip of a blunt, wide knife around the edge of each custard to release it from the cup. Using the knife or a narrow rubber scraper, carefully slide the custards (they will be fragile) out of the cups and directly into the soup, floating two in each bowl. Serve immediately.

SERVES 6

GARLIC CUSTARDS

Nonstick cooking spray for the muffin tin
1 cup heavy cream
3 garlic cloves, chopped
4 yolks from large eggs
1½ teaspoons soy sauce

Position a rack in the middle of the oven and preheat to 325 degrees F. Coat 12 cups of a mini muffin tin with the nonstick spray. Set the muffin tin in a large, shallow baking pan such as a jelly-roll sheet pan.

In a small saucepan over medium heat, combine the heavy cream and garlic and bring just to a simmer. In a medium bowl whisk together the egg yolks and soy sauce until well blended. Whisking constantly, pour the hot cream slowly through a strainer into the egg mixture; discard the chopped garlic.

Divide the warm custard mixture among the prepared muffin-tin cups, filling them full. Set the large baking pan in the oven; add hot water to the baking pan to come halfway up the sides of the cups of the muffin tin. Bake until the custards are puffed, golden, and evenly set, about 25 minutes. Remove the muffin tin from the hot water, set it on a rack, and cool the custards to room temperature before unmolding.

The custards can be prepared up to 1 day ahead; cover loosely and refrigerate, then return them to room temperature before using.

MAKES 12 CUSTARDS

FOUR ASIAN MUSHROOMS

MATSUTAKE

ALSO: WHITE PINE MUSHROOM, PINE MUSHROOM

U nbelievably expensive autumn delicacy in Japan, frequently given as corporate gifts in elaborately staged career moves. Sweetly pine-scented fungi are foraged (none are cultivated) near the roots of the red pine in China, Japan, and the Pacific Northwest (prices are less breathtaking in the United States).

Tightly capped number one specimens, enclosed in a kind of veil, are distinctly phallic; the price, the prestige, and the grade number drops as the caps open, yielding light brown to pale ivory flattish-topped mushrooms with bulbous stems.

Store: Wrap well; they dry out and spoil quickly. Cook: Traditionally broken into pieces rather than sliced and then simply simmered in a broth to be sipped—which shows off the unique piney fragrance—or grilled. The texture after cooking resembles, according to one expert, asparagus.

Dried: The piney essence is diminished, the texture meaty and satisfying.

ENOKI MUSHROOM

ALSO: ENOKITAKE, ENOKIDAKE, ENOK MUSHROOM, SNOW PUFF MUSHROOM, GOLDEN MUSHROOM, VELVET STEM

T he look—long, skinny white stems topped with tiny closed caps—is as unusual as the fruity taste and crunchy texture.

Cultivated in Japan and in the United States, enoki grow

in clumps on a sterilized mixture of rice bran and sawdust. Packed in sealed small bags, enoki should be firm and white, not brown and soft. Cut away the root end, separate the clusters and rinse.

Use raw in salads or on sandwiches, or heat briefly in soups just before serving.

STRAW MUSHROOM
ALSO: PADI-STRAW, PADDY STRAW

Grown on rotting rice straw; resemble small, almost-closed parasols with frilled edges; variegated tan to gray.

Mild mushroomy flavor and soft texture, especially in the more commonly found canned specimens; more flavor and texture found in dried versions, which remain slightly chewy and smoky even when reconstituted.

WOOD EAR
ALSO: TREE EAR, ELEPHANT EAR, CLOUD EAR, BLACK FUNGUS

These gray-black ear-shaped Chinese mushrooms (the larger specimens are dubbed cloud ears), once only available dried, are now being cultivated on the West Coast and are sold fresh in packages in Asian markets.

Fresh or reconstituted, they are chewy, moist, and gelatinous. All but the freshest specimens have little taste; reconstituted wood ears may be slightly smoky. Fresh wood ears can be frozen uncooked, but will last as long as a month, refrigerated; dried wood ears remain good for years.

Use for color and texture accents; rarely eaten alone.

DRIED MUSHROOM, BARLEY, AND LENTIL SOUP

Try this attractive, slightly smoky soup on a brisk fall day, accompanied with hearty whole-grain bread and followed by baked apples. It will be best when prepared a day in advance; a smoked ham hock can be substituted for the turkey wing.

1 ounce (about 1 cup) dried morels
3 cups homemade chicken stock or canned chicken broth
3 tablespoons unsalted butter
2 cups finely chopped yellow onions
2 large carrots, peeled and finely chopped
1½ teaspoons dried thyme, crumbled
2 bay leaves
5 cups water
1 large smoked turkey wing
½ cup pearl barley, rinsed
½ cup brown lentils, rinsed
1 teaspoon salt
½ teaspoon freshly ground black pepper

In a strainer under cold running water, thoroughly rinse the morels. In a small saucepan bring the chicken stock to a boil. In a small, heatproof bowl, combine the morels and boiling stock, cover, and let stand, stirring once or twice, until cool.

With a slotted spoon remove the morels from the soaking liquid, transfer them to a strainer, and rinse well under cold running water. Let the soaking liquid settle for 5 minutes, then pour

off and reserve the clear portion; discard the sandy residue.

In a 5-quart soup pot over medium heat, melt the butter. When it foams add the onions, carrots, thyme, and bay leaves; cover and cook, stirring once or twice, until the vegetables are tender and lightly colored, about 10 minutes.

Add the morels, their soaking liquid, the water, and the turkey wing and bring to a simmer. Cover partially and cook for 30 minutes. Remove the turkey wing and, when it is cool enough to handle, remove and discard the skin, then remove and chop any turkey meat.

Add the meat, barley, lentils, salt, and pepper to the soup and bring to a simmer. Cover partially and cook, stirring occasionally, until the soup is thick and the barley and lentils are just tender, about 30 minutes. Adjust the seasoning and discard the bay leaves before serving.

SERVES 6 TO 8 AS A MAIN COURSE

THE NATIONAL MUSHROOM HUNTING CHAMPIONSHIP

An annual contest, held over Mother's Day weekend in Boyne City, Michigan, celebrates the elusive morel. Hunters in five categories (resident and nonresident males and females, plus winners from previous years) compete for ninety minutes on Saturday. The top five hunters in each category then vie on Sunday, again for ninety minutes. Sheer quantity of morels collected decides the winner; in good years (moist, warm weather) a victor's take can exceed nine hundred mushrooms. Modest cash prizes supplement the mushroom bonanza for first, second, and third places. Local restaurants feature morel specialties. For more information, contact the Boyne City Chamber of Commerce; 616/582-6222.

STEAK SANDWICHES
with Mushroom–Red Wine Sauce

These hearty knife-and-fork sandwiches make an excellent supper dish, prime sirloin and robust cremini taking them far out of the ordinary and making them special enough for company. Serve the sandwiches with broiled tomatoes, shoestring French fries, and a crisp watercress salad and drink an American Pinot Noir or a *grand cru* Beaujolais. Use either of these for the marinade as well.

¾ cup medium-dry red wine
1½ pounds well-trimmed sirloin steak, about 1 inch thick
2 tablespoons vegetable oil
4 tablespoons (½ stick) unsalted butter
½ cup minced shallots
2 garlic cloves, minced
1¼ pounds fresh cremini, thickly sliced
1¼ teaspoons salt
1½ cups homemade beef stock or canned beef broth
2 tablespoons cornstarch
¾ teaspoon freshly ground black pepper
⅓ cup finely chopped fresh flat-leaf parsley
4 large, thick slices country-style bread

In a shallow dish pour the wine over the steak. Cover and marinate at room temperature for 4 hours, turning once or twice.

Preheat the broiler. Remove the steak, reserving the wine, and pat the meat dry. Set a large, heavy skillet over medium-high

heat. When it is very hot, add the vegetable oil. Add the steak and immediately turn it once to oil both sides. Cook for 7 minutes, then turn and cook for another 7 minutes for medium-rare, or until done to your liking. Transfer the steak to a cutting board and tent with foil.

Pour off the fat in the skillet. Return the skillet to medium-high heat, add the reserved wine, and cook, stirring and scraping the bottom of the skillet, until the wine is reduced to ¼ cup, about 3 minutes. Set aside.

Meanwhile, in another large skillet over medium-low heat, melt the butter. When it foams add the shallots and garlic, cover, and cook, stirring once or twice without browning, for 4 min-

utes. Add the mushrooms and 1 teaspoon of the salt, cover, and cook, stirring once or twice, until the mushrooms are beginning to render their juices, about 5 minutes.

In a small bowl stir 2 tablespoons of the beef stock into the cornstarch. Add the remaining beef stock to the mushrooms, then add the reduced wine to the mushrooms. Raise the heat and simmer briskly, uncovered, stirring once or twice, until the liquid is reduced by half, about 4 minutes. Stir in the cornstarch mixture and ½ teaspoon of the pepper and simmer the sauce, stirring often, until thick and glossy, about 2 minutes. Stir in the parsley and adjust the seasoning.

Meanwhile, under the broiler, toast the bread slices on one side only. Carve the steak, across the grain and at a slight angle, into at least 12 thin slices; stir any juices from the cutting board into the mushroom sauce. Set each slice of bread, untoasted side up, on a plate. Arrange the sliced steak over the bread, dividing it evenly and using it all. Season to taste with the remaining ¼ teaspoon each salt and pepper. Spoon the mushroom sauce over and around the sandwiches, dividing it evenly and using it all. Serve immediately.

SERVES 4

GRILLED
TURKEY-SHIITAKE BURGERS
with Plum Mayonnaise

Alternatives to traditional beef burgers are a sign of the times. Most eaters make such changes for health reasons, but when a nonbeef burger is as delicious as this one, nutritional persuasion takes a back seat to good old-fashioned flavor. Various products are sold labeled "plum sauce"; for the mayonnaise, select one that is thick and dark crimson, not clear and marmaladelike. These burgers taste best when grilled outdoors, but can also be broiled or panfried if you prefer.

1½ tablespoons unsalted butter
2 green onions, green tops included, sliced
2 teaspoons minced fresh ginger
2 garlic cloves, minced
½ pound fresh shiitakes, finely chopped
1 tablespoon soy sauce
1 pound ground turkey
¼ cup prepared mayonnaise
3 tablespoons Chinese plum sauce
¼ teaspoon hot-pepper sauce
2 cups wood smoking chips, preferably applewood
4 hamburger buns, split
4 slices tomato
4 leaves romaine or other crisp lettuce

In a large skillet over low heat, melt the butter. Stir in the onions, ginger, and garlic; cover and cook, stirring once or twice, for 5 minutes. Raise the heat slightly, stir in the mushrooms and soy sauce, re-cover, and cook, stirring once or twice, until the mushrooms render their juices, about 4 minutes. Uncover the skillet, raise the heat slightly, and cook, stirring often, until the juices have evaporated, 1 to 2 minutes. Remove from the heat and cool to room temperature.

In a large bowl thoroughly stir together the turkey and the mushroom mixture. Firmly shape the meat mixture into 4 thick patties. Cover and refrigerate for 1 hour to firm the patties.

In a small bowl whisk together the mayonnaise, plum sauce, and hot-pepper sauce; cover and refrigerate. Soak the wood chips in water to cover generously for 1 hour.

Light a charcoal fire and let it burn down until the coals are evenly white or preheat a gas grill (medium). Drain the wood chips and scatter them over the coals or grillstones. Position a rack about 6 inches above the heat source.

When the chips are smoking, lay the turkey patties on the grill. Cover and cook 4 minutes. Turn and cook until the burgers are lightly browned and cooked through while remaining juicy, another 3 to 4 minutes. Transfer to a plate.

Toast the cut sides of the buns on the grill, if desired, and then set the bottoms on 4 plates. Set the burgers on the bun bottoms, top each with a slice of tomato and a leaf of lettuce, and set the bun tops in place. Serve immediately, passing the plum mayonnaise at the table.

SERVES 4

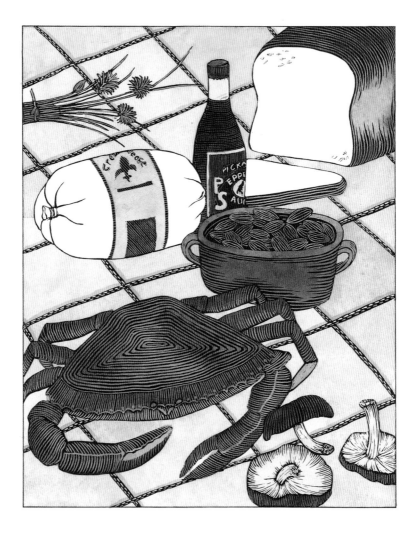

TOASTED CRAB, CHEESE, AND MUSHROOM SANDWICHES

Back before almost everything was grilled, pretty much only cheese sandwiches were. But then they were actually griddled (well, fried), which leads me to the *toasted* in this recipe's title— not as much greasy fun as frying, perhaps, but more accurate. Also a far cry from Mom's grilled cheese is the filling of these opulent treats: Shiitake mushrooms, lump crab meat, toasted almonds, and fresh chives mark them as company fare, not a quick family supper. Serve them with crunchy sweet-and-sour coleslaw and best-quality (even homemade) potato chips.

¼ cup natural raw almonds (unblanched)
2 tablespoons unsalted butter, plus 5 tablespoons
 unsalted butter, softened
1 pound fresh shiitakes, thinly sliced
½ teaspoon salt
6 ounces cream cheese, preferably free of stabilizers,
 at room temperature
¼ cup milk
1 tablespoon hot-pepper sauce
2 tablespoons minced fresh chives
½ pound fresh lump crab meat, picked over for
 cartilage and shell fragments
12 thin slices good-quality firm white sandwich bread,
 from a 5-by-9-inch loaf

Position a rack in the middle of the oven and preheat to 375 degrees F. Spread the almonds in a single layer in a shallow metal

pan, like a cake tin, and toast them, stirring once or twice, until they are crisp, lightly browned, and fragrant, about 10 minutes. Remove from the pan and cool to room temperature. Coarsely chop the almonds. Set aside.

In a large skillet over medium heat, melt the 2 tablespoons butter. Add the mushrooms and salt, cover, and cook, stirring once or twice, until they have softened and are just beginning to render their juices, about 4 minutes. Uncover and cook, tossing

and stirring often, until the juices have evaporated and the mushrooms are tender and lightly browned, about 2 minutes. Remove from the heat and cool to room temperature.

In a medium bowl stir together the cream cheese, milk, and hot-pepper sauce. Stir in the reserved chopped almonds and the chives. Gently fold in the crab meat; do not overmix.

Spread one side of each slice of bread with the crab meat mixture, dividing it evenly and using it all. Top the crab mixture on 6 slices of bread with the mushrooms, spreading them in an even layer to the crusts and using them all. Invert the remaining 6 slices of bread, crab mixture down, onto the mushrooms and press gently with the palm of your hand. Brush both sides of each sandwich lightly and evenly with the remaining 5 tablespoons butter.

Set 2 large skillets over medium heat. When they are hot, lay the sandwiches in the skillets, cover, and cook, turning them once, until both sides are crisp and golden and the filling is hot and creamy, about 4 minutes per side.

Transfer the sandwiches to a board, cut them in half on the diagonal, and serve immediately.

SERVES 6

CHAPTER THREE

PASTAS, PIZZAS & CALZONES

MACARONI BAKED
with Mushrooms, Ham, and Cheese

MUSHROOM FETTUCCINE "ALFREDO"

PASTA WITH MUSHROOMS, BEANS, AND PROSCIUTTO

ANDOUILLE, MUSHROOM, AND CHEESE CALZONES

CALIFORNIA ROOM-SERVICE PIZZAS

LESS-THAN-THIRTY-MINUTES HOME-BAKED PIZZA

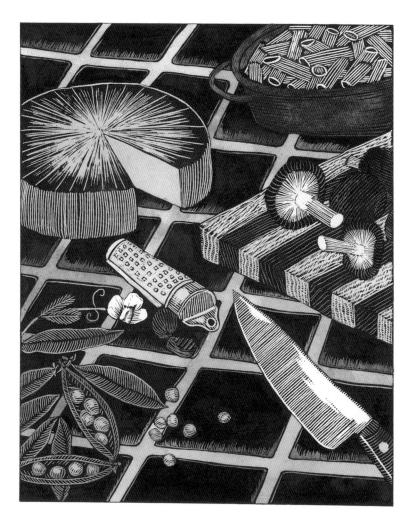

MACARONI BAKED
with Mushrooms, Ham, and Cheese

Bearing only the slightest resemblance to ordinary macaroni and cheese, this crusty pasta casserole gains real distinction from the addition of mushrooms, smoky ham, and sweet peas. Serve it on the same plate with a vinaigrette-dressed green salad and pass hot corn bread.

8 tablespoons (1 stick) unsalted butter, plus unsalted butter
for the baking dish
1 pound fresh cremini, quartered
1 pound fresh shiitakes, quartered
4 teaspoons salt
¾ teaspoon freshly ground black pepper
2½ cups milk
3 tablespoons unbleached all-purpose flour
Pinch of freshly grated nutmeg
10 ounces medium-sharp Cheddar cheese, grated
10 ounces Monterey Jack cheese, grated
1 pound imported dried penne rigate or other short,
ridged, tubular semolina pasta
½ pound smoked ham, well trimmed and cut into ½-inch dice
1 package (10 ounces) frozen peas, thawed and drained
3 tablespoons freshly grated Parmesan cheese
3 tablespoons fine dried bread crumbs

In a large skillet over medium heat, melt 3 tablespoons of the butter. When it foams add the cremini and shiitakes and season

with 1 teaspoon of the salt and ¼ teaspoon of the pepper; cover and cook, tossing and stirring once or twice, until the mushrooms begin to render their juices, about 5 minutes. Transfer the mushrooms to a strainer set over a bowl.

In a small saucepan, bring the milk just to a boil. In a medium, heavy saucepan over low heat, melt 3 tablespoons of the butter. Whisk in the flour and cook, stirring often without allowing the flour to brown, for 5 minutes. Remove from the heat and gradually whisk the hot milk into the flour mixture. Whisk in the juices from the bowl beneath the mushrooms. Return the saucepan to low heat and whisk in ½ teaspoon of the salt, the remaining ½ teaspoon pepper, and the nutmeg. Bring to a simmer, cover partially, and cook, stirring often, until the sauce has thickened slightly, about 15 minutes. Remove from the heat and stir in the Cheddar and Monterey Jack cheeses and the mushrooms.

Meanwhile, position a rack in the middle of the oven and pre-heat to 400 degrees F. Generously butter a 3½-quart baking dish about 3 inches deep.

Fill a large pot with water and bring it to a boil. Stir in the penne and the remaining 2½ teaspoons salt and cook the pasta, stirring occasionally, until it is just tender, 8 to 10 minutes, depending upon the pasta brand; drain well. Return the pasta to its hot pan. Add the mushroom sauce, ham, and peas and stir well. Transfer the pasta mixture to the prepared dish, spreading it evenly. The casserole can be assembled to this point up to 1 hour in advance. Cover and hold at room temperature.

In a small bowl stir together the Parmesan cheese and bread crumbs. Sprinkle evenly over the pasta. Cut the remaining 2 tablespoons butter into small pieces and scatter them over the top of the casserole. Bake until the sauce is bubbling and the top and sides of the pasta are crisp and brown, about 35 minutes. Remove from the oven and let stand in the dish on a rack for 5 minutes before serving.

SERVES 8

SHIITAKE

ALSO: FOREST MUSHROOM,
GOLDEN OAK MUSHROOM,
CHINESE BLACK MUSHROOM

Flattish, coolie hat-shaped cap with medium brown hide, ivory interior, woody stem. Size can range from two-inch caps to five inches or larger. Dried specimens include large, tan Japanese imports, packed in plastic trays, as well as button-small, almost-black Chinese varieties in boxes or cellophane bags.

Fresh: Meaty texture with a strong, gamy, slightly garlicky taste. Reconstituted dried: Smoky, tobaccolike flavor; without a lengthy simmer the texture remains fairly chewy. The stems of both fresh and dried shiitakes, except in the smallest specimens, are rather tough and are usually removed and simmered in stocks, then discarded.

Grows year around with fall and spring peaks on oak or other hardwood logs or sterile oak-chip medium (name translates literally as "oak mushroom"); widely cultivated in the Orient for centuries (may be the world's oldest farmed mushroom, although some sources say the Japanese learned their techniques from the French) and in this country since the late seventies. Among the most successful, versatile, and useful of the cultivated exotics; shiitakes should not be limited to Asian preparations.

An excellent keeper; properly stored (in a cloth bag, a clean pillowcase, or covered with dampened cheesecloth) they will hold for a week or longer.

MUSHROOM FETTUCCINE
"ALFREDO"

The affinity of mushrooms for cream is undeniable and, in this variation on a classic pasta dish, irresistible. Invented (or at least marketed brilliantly) at a Roman restaurant whose eponymous host tossed each portion with a fork of gold, this is a rich pasta, better suited as a starter then a main course. Follow it with something plain—roast chicken or grilled seafood—and drink a light crisp, low-alcohol Italian Chardonnay.

2 cups heavy cream
4 teaspoons salt
Pinch of freshly grated nutmeg
4 tablespoons (½ stick) unsalted butter
¼ cup minced shallots
2 garlic cloves, minced
1 pound fresh cremini, thickly sliced
½ pound fresh shiitakes, thickly sliced
1½ cups freshly grated Parmesan cheese
½ teaspoon freshly ground black pepper
1 pound fresh fettuccine

In a medium saucepan over moderate heat, combine the cream, ¾ teaspoon of the salt, and the nutmeg. Bring to a boil, then lower the heat and simmer uncovered, stirring once or twice, until the cream is reduced by about one fourth and has thickened slightly, about 15 minutes.

Meanwhile, in a large skillet over low heat, melt the butter. Add the shallots and garlic, cover, and cook, stirring once or twice, for 4 minutes. Raise the heat slightly, add the mushrooms and 1 teaspoon of the salt, re-cover, and cook, stirring once or twice, until the mushrooms just begin to render their juices, about 4 minutes. Uncover, raise the heat to medium-high, and cook, tossing and stirring often, until the juices have evaporated, 1 to 2 minutes. Stir in the reduced cream, ⅓ cup of the grated cheese, and the pepper; cover and keep warm.

Fill a very large pot with water and bring to a boil. Stir in the remaining 2¼ teaspoons salt, add the fettuccine, and cook, stirring once or twice, until the pasta is just tender without being mushy, 2 to 3 minutes. Drain immediately and return the pasta to the hot pan. Add the mushroom mixture and toss well.

Divide the pasta among 8 warmed plates and spoon any sauce remaining in the pan evenly over the top. Serve immediately, accompanied with the remaining cheese.

SERVES 8 AS A FIRST COURSE

66

PASTA WITH MUSHROOMS, BEANS, AND PROSCIUTTO

This could just as easily be called beans with pasta, since the two starches are about evenly represented. Tossed with meaty cremini, sweet carrots, and silky prosciutto and seasoned with plenty of garlic and fresh herbs, they team to produce a hearty and vibrant main course.

¾ *cup dried cannellini (white kidney) beans, picked over*
4½ *teaspoons salt*
6 *ounces dried short, thick, curly pasta, such as elbow*
 twists or fusilli
4 *tablespoons olive oil*
4 *large carrots, peeled and cut into ⅛-inch-thick slices*
4 *garlic cloves, minced*
½ *teaspoon crushed red pepper*
¾ *pound fresh cremini, quartered*
2 *cups lightly salted homemade chicken stock or reduced-*
 sodium canned chicken broth
¼ *pound sliced prosciutto, cut crosswise into ½-inch-wide strips*
1 *tablespoon minced fresh marjoram, oregano, or rosemary*
Freshly grated pecorino romano cheese

In a bowl combine the beans and cold water to cover them generously. Let soak for 24 hours. Drain. In a medium pan combine the beans with fresh cold water to cover them generously. Set over medium heat and bring to a simmer. Cook uncovered, stirring once or twice, for 25 minutes. Stir in 2 teaspoons of the

salt and cook until the beans are just tender, 10 to 15 minutes. Cool the beans to room temperature in their cooking water; drain and set aside.

Fill a large pot with water and bring it to a boil. Stir in 2 teaspoons of the salt and the pasta and cook, stirring once or twice, until barely tender, about 8 minutes, depending upon the pasta shape and brand. Drain and toss with 1 tablespoon of the oil.

Meanwhile, in a large, deep skillet over low heat, warm the remaining 3 tablespoons olive oil. Add the carrots, cover, and cook, stirring occasionally, until lightly colored, about 8 minutes. Stir in the garlic and crushed red pepper, then add the mushrooms and season with the remaining ¼ teaspoon salt. Re-cover, raise the heat to medium, and cook, stirring once or twice, until the mushrooms just begin to render their juices, about 4 minutes.

Add the reserved beans, pasta, and chicken stock to the skillet and bring to a simmer. Cover partially and cook, stirring often, until about half the stock has been absorbed, about 4 minutes. Stir in the prosciutto strips and marjoram and remove from the heat.

Divide the pasta, including any unabsorbed liquid, among 4 wide, shallow bowls. Serve immediately. Pass the grated cheese at the table.

SERVES 4

ANDOUILLE, MUSHROOM, AND CHEESE CALZONES

These crosscultural calzones (Cajun sausage, Italian mushrooms, French goat cheese) are perfect at lunch or for an informal supper, served on the same plate with a crisp, tart green salad and washed down with an uncomplicated red wine. Either Spanish chorizo or pork hot links can be substituted for the andouille.

1 large sweet red pepper
1 tablespoon olive oil
5 ounces andouille (spicy smoked pork sausage), diced
¾ pound fresh cremini, cut into ½-inch chunks
2 green onions, green tops included, sliced
½ teaspoon salt
2 tablespoons cornmeal
Flour for the work surface
Dough for Pizzas and Calzones (recipe follows)
6 ounces soft, fresh goat cheese, crumbled
1 cup (about 4 ounces) grated mozzarella cheese
 (supermarket type, not fresh)

In the open flame of a gas burner, or under a preheated broiler, roast the pepper, turning it occasionally, until the peel is evenly charred. In a bowl covered with a plate, or in a closed paper bag, steam the pepper until cool. Rub away the charred peel, stem and core the pepper, and cut the flesh into julienne strips. Set aside.

In a medium skillet over moderate heat, warm the olive oil. Add the andouille and cook, stirring once or twice, until lightly

browned, about 5 minutes. Add the mushrooms, green onions, and salt and toss to combine; cover and cook, stirring once or twice, until the mushrooms just begin to render their juices, about 4 minutes. Raise the heat and cook uncovered, stirring often, until the juices have evaporated, 1 to 2 minutes. Cool to room temperature.

Position a rack in the middle of the oven and preheat to 500 degrees F. Sprinkle a large, heavy baking sheet with the cornmeal.

Lightly flour the work surface. Pat out 1 ball of dough into a 6-inch round. Scatter one fourth of the goat cheese over half the dough, leaving a ½-inch border. Top the goat cheese with one fourth of the mushroom mixture; top the mushrooms with one fourth of the julienned pepper; and top the peppers with one fourth of the mozzarella. Use a cupped hand to compact the filling lightly into an oval. Stretch and fold the uncovered half of the dough over the filling to enclose it and form a half round. Crimp the edges to seal firmly. Use a long spatula to transfer the calzone to the prepared baking sheet. Repeat with the remaining ingredients.

Bake the calzones, turning the baking sheet 180 degrees on the rack after 10 to 15 minutes, until the bottoms are crisp, the tops lightly browned, and the cheeses bubbling, 20 to 25 minutes' total cooking time. Cool slightly on a rack; serve hot or warm.

SERVES 4

DOUGH FOR PIZZAS
AND CALZONES

1½ teaspoons active dry yeast
1¼ cups lukewarm (105 to 115 degrees F) water
2 teaspoons salt
About 3¼ cups unbleached all-purpose flour
4 teaspoons olive oil

In a medium bowl sprinkle the yeast over the water. Stir to dissolve and then let stand for 5 minutes. Add the salt, then whisk in 2 to 2½ cups of the flour to form a soft dough.

Dust the work surface with ¼ cup of the flour. Turn the dough out onto the prepared surface. Knead until smooth and elastic, about 5 minutes, adding up to ½ cup more of the flour if the dough remains sticky. Divide the dough into 4 pieces; shape each piece into a ball.

Divide the olive oil among 4 small bowls. Place 1 ball of dough in each bowl, turn to coat with oil, cover tightly with plastic, and refrigerate for at least 12 hours or for up to 48 hours.

Makes dough for 4 small pizzas or 4 calzones

CALIFORNIA
ROOM-SERVICE PIZZAS

While it may be true that room-service food tastes great simply because of the comfort in which it is eaten, I still think the pizza delivered to my Stanford Court hotel room from the downstairs restaurant, Fournou's Ovens, some years ago was exceptional. Although used in small amounts, the varied toppings—smoked Ozark ham, caramelized onions, roasted red pepper, shiitakes, and Fontina cheese—combined to make for a very big effect. You needn't check into a San Francisco hotel to share that savory experience. My memory of that delicious pizza is indelible and my recipe below duplicates it precisely.

1 large sweet red, orange, or yellow pepper
4 tablespoons olive oil
1 yellow onion (about ½ pound), thinly sliced
4 large fresh shiitakes (about ¼ pound total), sliced
¼ cup cornmeal, for the baking sheets
Flour for the work surface
Dough for Pizzas and Calzones (page 71)
½ pound Fontina Valle d'Aosta, Comté, or Gruyère cheese, grated
⅓ pound best-quality baked smoked ham, very thinly sliced
2 tablespoons minced fresh marjoram, thyme, or oregano
Freshly ground black pepper

In the open flame of a gas burner, or under a preheated broiler, roast the pepper, turning it occasionally, until the peel is evenly charred. In a bowl covered with a plate, or in a closed paper bag,

steam the pepper until cool. Rub away the charred peel, stem and core the pepper, and cut the flesh into julienne strips.

In a medium skillet over moderately high heat, warm 2 tablespoons of the olive oil. Add the onion and cook, tossing and stirring, until it is limp and lightly browned, about 4 minutes. With a slotted spoon transfer the onion to a small bowl.

Return the skillet to moderately high heat and add the remaining 2 tablespoons olive oil. Add the shiitakes and cook, tossing and stirring, for 2 minutes. The mushrooms should retain most of their texture. Transfer to a small bowl.

Position racks in the upper and lower thirds of the oven and preheat to 500 degrees F. Evenly sprinkle two large baking sheets with the cornmeal.

Lightly flour the work surface. One at a time, using your fingertips, pat out each ball of pizza dough into a 7-inch round. Transfer the rounds as you go to the prepared baking sheets. Sprinkle the cheese evenly over the dough rounds, leaving a ½ inch border uncovered. Tear the ham slices into bite-sized pieces and scatter evenly over the cheese. Place dollops of the browned onions randomly around the pizzas. Scatter the pepper strips and shiitakes evenly over the pizzas. Sprinkle the pizzas with the marjoram and season generously with pepper.

Bake the pizzas for about 15 minutes, exchanging the position of the pans on the racks from top to bottom and from front to back at the halfway point. The cheese should be melted, the toppings lightly colored, and the crust crisp and golden brown. Cut the pizzas into wedges if desired and serve hot.

SERVES 4

LESS-THAN-THIRTY-MINUTES HOME-BAKED PIZZA

You won't need to endure canned mushrooms on your pizza, and you won't have to tip a delivery boy when this pantry-based recipe is on the menu. Convenient presliced pepperoni, grated "pizza" cheese, purchased tomato or pizza sauce, and the increasingly available Boboli brand bread shell all combine with fresh cremini (or other mushrooms of your choice) to produce a hot pizza only minutes after the inspiration strikes.

2 tablespoons olive oil
1 garlic clove, minced
¼ teaspoon dried oregano, crumbled
¼ teaspoon crushed red pepper
½ pound fresh cremini, sliced
½ teaspoon salt
1 large (12 inches in diameter) Boboli-brand Italian bread shell
½ cup purchased thick tomato sauce or pizza sauce
1 cup (about 4 ounces) grated mozzarella (supermarket
 type, not fresh)
1 ounce (about 16 slices) sliced pepperoni

Position a rack in the upper third of the oven and preheat to 450 degrees F. In a medium skillet over low heat, warm the olive oil. Add the garlic, oregano, and crushed red pepper, and cook, stirring often, for 3 minutes. Add the mushrooms and salt and toss to combine; cover and cook, stirring often, until the mushrooms begin to render their juices, about 4 minutes. Uncover, raise the

heat slightly, and cook, tossing and stirring often, until the juices have evaporated and the mushrooms are lightly browned, about 3 minutes. Remove from the heat.

Spread the tomato sauce evenly in the central depression of the bread shell, avoiding the wide raised crust. Sprinkle the cheese evenly over the sauce. Scatter the mushrooms evenly over the cheese. Lay the pepperoni slices over the mushrooms. Set the bread shell directly on the oven rack and bake until the cheese has melted and is bubbling and the bread shell is lightly browned, 10 to 12 minutes. Transfer to a board and let rest for 5 minutes, then cut into 6 wedges. Serve hot.

SERVES 2 OR 3

POULTRY, SEAFOOD & MEATS

PARCHMENT-BAKED SALMON
with Mushrooms, Green Chilies, and Corn

PANFRIED CHICKEN-AND-MUSHROOM SAUSAGES

RISOTTO WITH PORCINI, SHRIMP, AND MINT

BLANQUETTE OF LAMB
with Asparagus and Morels

CHIANTI BEEF STEW
with Porcini

COUNTRY MEAT LOAF
with Mushroom Gravy

RABBIT BRAISED
with Mushrooms, Root Vegetables, and Bacon

QUICK PORK STROGANOFF

PARCHMENT-BAKED SALMON
with Mushrooms, Green Chilies, and Corn

Inspired by the flavor of scarce *huitlacoche* and the chilies with which it is often paired, the mixture of cremini, corn, and poblanos that tops these salmon fillets as they bake is a colorful and delicious garnish. Two poblanos will provide rich taste and just the right amount of heat; four Anaheim-type long green chilies, which may be milder, can be substituted. Let diners slit open their own parchment packets after they are served, warning them first of the hot steam that will escape.

2 large fresh poblano chilies
2 tablespoons olive oil, plus additional olive oil
 for the parchment packets
2 garlic cloves, minced
¾ pound fresh cremini, sliced
1 teaspoon salt
2 ears of tender, sweet corn, shucked
2 tablespoons fish stock or bottled clam juice
2 tablespoons medium-dry white wine
1 tablespoon fresh lime juice
4 salmon fillets (1½ to 2 pounds total), about 1 inch
 thick, at room temperature
Freshly ground black pepper

In the open flame of a gas burner, or under a preheated broiler, roast the chilies, turning them occasionally, until the peels are lightly but evenly charred. In a bowl covered with a plate, or in a

closed paper bag, steam the chilies until cool. Rub away the charred peels, stem and core the chilies, and cut the flesh into narrow julienne strips.

In a large skillet over medium heat, warm the 2 tablespoons olive oil. Add the julienned poblanos and the garlic, cover, and cook, stirring once or twice, for 4 minutes. Add the cremini and ½ teaspoon of the salt, re-cover, and cook, stirring once or twice, until the mushrooms begin to render their juices, about 4 minutes. Uncover, raise the heat, and cook, tossing and stirring, until the juices have evaporated, 1 to 2 minutes. Remove from the heat and cool to room temperature.

One at a time, hold the ears of corn over a large bowl and, with a sharp knife, cut off the kernels. Scrape the milky juices from the cob into the bowl. Stir in the mushroom mixture, the stock, wine, lime juice, and ¼ teaspoon of the salt.

Position a rack in the middle of the oven and preheat to 475 degrees F. Fold four 14-inch squares of parchment paper in half. With scissors, cut each piece of parchment into a large heart shape.

Open the parchment hearts and lay them on the work surface. With a pastry brush, lightly oil the exposed surfaces of the hearts. Set a salmon fillet in the center of one half of a parchment heart. Season lightly with some of the remaining ¼ teaspoon salt and black pepper to taste. Spoon one fourth of the mushroom mixture and any juices from the bowl over the salmon fillet. Fold the other half of the parchment heart over the salmon and fold and crimp the edges tightly shut. Repeat with the remaining ingredients. With a long spatula, transfer the packets to a large baking sheet, spacing them well apart. Brush the tops of the parchment packets lightly with olive oil.

Bake until the packets are puffed and lightly browned and the salmon is barely done through and is flaking (open one packet to check), 12 to 14 minutes. With a long spatula transfer the packets to plates and serve immediately.

Serves 4

TROMPETTE
DE LA MORT

ALSO: TRUMPET OF DEATH,
HORN OF PLENTY, BLACK CHANTERELLE

V elvety gray to soot black and somewhat thin-walled, even papery, trumpet-shaped trompettes de la mort are stunning mushrooms, bringing real visual drama to the dish in which they are used. The high season for foraged trompettes (none are cultivated) runs from late summer through autumn, but some are found in spring as well; supplies are always rather sporadic.

Called the poor man's truffle, and frequently used in substitution, trompettes leave some unimpressed with their flavor (which doesn't particularly resemble truffles), but most who have cooked them praise their dark, smoky, and slightly mysterious taste. They are especially lovely with sweet white-fleshed fish (sole and halibut, for example) and chicken, but are frequently paired with red meats as well. Chefs who do feature them on restaurant menus frequently resort to one of the mushrooms's less ominous names to avoid frightening off the customers.

Dried: The great folds and whorls of the fresh specimens dehydrate to almost nothing, but the haunting taste remains.

PANFRIED CHICKEN-
AND-MUSHROOM SAUSAGES

These delicate white sausages, spangled with black, smoky trompettes de la mort and chopped pistachios, are panfried, sliced, and napped with a light and winy sauce. The ideal accompaniments are creamy mashed potatoes and garlicky stir-fried watercress. Sausage casings are inexpensive (order them from any good butcher) and simple to stuff, but you may omit them and form the meat mixture into eight small patties if you prefer.

About 5 feet pork sausage casings
1 tablespoon distilled white vinegar
2 tablespoons unsalted butter
½ pound fresh trompettes de la mort
1½ teaspoons salt
1½ pounds skinless, boneless chicken breast meat,
* trimmed and cut into 1-inch cubes*
½ pound skinless, boneless chicken thigh meat,
* trimmed and cut into 1-inch cubes*
¼ cup heavy cream
½ teaspoon freshly ground black pepper
Pinch of freshly grated nutmeg
½ cup coarsely chopped pistachios, from about ½ pound
* unshelled natural (undyed) nuts*
2 tablespoons vegetable oil
1 cup homemade chicken stock or canned chicken broth
¼ cup medium-dry white wine
¼ teaspoon fresh lemon juice

Fill a large bowl with cold water, add the sausage casings and vinegar, and soak for 1 hour. Drain. Rinse the casings by slipping one end over the faucet and running cold water through it. Cut the casings into four 1-foot sections (avoid any holes) and cover with cold water until using.

In a large skillet over medium heat, melt the butter. When it foams add the mushrooms and ½ teaspoon of the salt, cover, and cook, stirring once or twice, until the mushrooms have rendered their juices and are tender, about 5 minutes. With a slotted spoon transfer the mushrooms to a strainer. Hold the strainer over the skillet and press with the back of the spoon to extract as much liquid from the mushrooms as possible. Cool and chop the mushrooms; set aside. Transfer the mushroom juices from the skillet to a small bowl, cover, and refrigerate.

In a food processor combine the chicken breast and thigh meat, heavy cream, the remaining 1 teaspoon salt, the pepper, and nutmeg and process until almost smooth (some slight texture should remain). Transfer the chicken mixture to a bowl. Add the mushrooms and pistachios and mix lightly until evenly combined.

Tie a knot at one end of a section of casing. Insert the end of a pastry bag fitted with a large, plain tip into the open end of the casing and gather the casing up onto the tip. Fill the pastry bag with one fourth of the sausage mixture. Force the mixture into the casing, sliding the casing off the pastry tip as it fills. Stop occasionally to shape the sausage. Pierce any air bubbles with a fine needle. Remove the filled sausage from the pastry tip. Tie a knot in the open end and trim any excess casing. Repeat with the remaining filling and casings. Wrap the sausages well in plastic and refrigerate overnight.

In a large skillet over medium heat, warm the vegetable oil. Add the sausages and cook, turning often, until they are well browned and just cooked through, about 12 minutes. Transfer the sausages to a plate and keep them warm; discard the oil but do not clean the skillet.

Set the skillet over high heat. Add the stock, wine, reserved mushroom juices, and lemon juice and bring to a boil. Cook uncovered, stirring often and scraping the pan, until the liquid has reduced by half and is slightly syrupy, about 6 minutes. Adjust the seasoning.

Cut the sausages on the diagonal into 1-inch-thick slices; arrange the slices, overlapping slightly, on 4 plates. Nap the sausages with the pan sauce and serve immediately.

SERVES 4

HUITLACOCHE

ALSO: CUITLACOCHE,
MAIZE MUSHROOM

Known in the United States as corn smut, a field disease that can destroy a farmer's entire crop, but in Mexico prized as a rare delicacy. The swollen, blackened kernels with crisp, silvery skin and a delicate taste are much esteemed.

Most American farmers still chop off and destroy infected ears, but demand by adventurous restaurant chefs has huitlacoche occasionally turning up at fancy produce stores and farmer's markets during corn season.

Mild flavor, resembling a cross between corn and mushrooms (fresh Mexican huitlacoche is more potent). Best cooked, rather than raw; can be used in any dish where mushrooms would be good, especially those also containing corn, pork, or chilies.

Canned: Produced in Mexico under the Herdez label, is given reasonable marks by experts as a substitute for fresh. Given the small supply imported to the United States and the keen competition for it among savvy cooks, canned huitlacoche may be even more difficult to locate than fresh.

RISOTTO WITH PORCINI, SHRIMP, AND MINT

A proper risotto is made with Italian short-grain Arborio rice. Stirred almost constantly with small additions of hot stock, the rice gradually becomes tender while its starches thicken the stock into a luscious, slightly soupy sauce. Tinted faintly pink with a bit of tomato sauce, this risotto of poached shrimp, tiny peas, and fresh mint makes a lovely springtime dinner starter or luncheon main course. Later in the season the shrimp can be grilled and basil can replace the mint, producing a completely different dish. Italian tradition withholds grated cheese from seafood dishes, a practice I suggest you follow here, to best enjoy the risotto's sweet freshness.

1 ounce (about 1 cup) dried porcini
1 cup medium-dry white wine
6 cups homemade chicken stock or canned chicken broth
1 pound medium shrimp, peeled and deveined, shells reserved
6 tablespoons (¾ stick) unsalted butter
1 cup minced yellow onions
2 garlic cloves, minced
1½ cups (about 10 ounces) Arborio rice
¾ cup Fresh Tomato Sauce (page 117) or other prepared
 good-quality meatless tomato sauce such as marinara sauce
1 cup frozen tiny peas, thawed and drained
¼ cup minced fresh mint, plus fresh mint sprigs
 as an optional garnish

In a strainer under cold running water, thoroughly rinse the porcini. In a small saucepan bring the wine to a boil. In a small, heatproof bowl, combine the porcini and boiling wine, cover, and let stand, stirring once or twice, until cool.

With a slotted spoon remove the porcini from the soaking liquid; mince the mushrooms and set aside. Let the liquid settle for 5 minutes, then pour off and reserve the clear portion; discard the sandy residue.

In a medium pan combine the soaking liquid and stock. Set over medium-high heat and bring to a boil. Add the shrimp and cook until curled and pink, about 1½ minutes. With a slotted spoon transfer the shrimp to a bowl and reserve. Add the shrimp shells to the boiling stock, lower the heat slightly, cover, and simmer, stirring once or twice, for 5 minutes. Strain the stock and discard the shells.

Return the stock to the pan, set over low heat, and bring just to a simmer. Meanwhile, in a heavy 4-quart saucepan over low heat, melt the butter. Add the onions, garlic, and porcini. Cover and cook, stirring once or twice, until the onions are tender, about 8 minutes. Add the rice and stir to coat the grains with butter. Stir in 1½ cups of the simmering stock. Bring the risotto to a simmer and cook uncovered, stirring often, until the rice has absorbed most of the stock, about 7 minutes.

Continue to cook the risotto, adding simmering stock ½ cup at a time as each previous addition of stock is absorbed. Stir often (although not constantly); the grains should be tender but still slightly firm to the bite after about 30 minutes (the rice may not require all of the stock).

Stir in the tomato sauce and cook another 5 minutes. Add the shrimp and peas and cook until they are heated through, another

1 or 2 minutes; the risotto should be slightly soupy. Stir in the minced mint, remove from the heat, and let stand, covered, for 1 minute. Serve immediately on warmed plates, garnished with sprigs of mint if desired.

SERVES 6 AS A MAIN COURSE, 8 AS A STARTER

BLANQUETTE OF LAMB
with Asparagus and Morels

A blanquette is a "white" stew (the meat is not browned) and the pale, creamy results are perfectly suited to show off the clear but subtle flavors of lamb, asparagus, and smoky-tasting dried morels.

1 ounce (about 1 cup) dried morels
About 5½ cups homemade chicken stock or canned chicken broth
3 pounds well-trimmed, boneless lean lamb shoulder
* or leg, cut into 1½-inch cubes*
1 large yellow onion
1 whole clove
1 large leek, white part only, partially split
2 celery stalks, including leafy tops
1 bay leaf
6 sprigs fresh flat-leaf parsley
1 carrot, peeled
½ teaspoon dried thyme, crumbled
2½ teaspoons salt
Tips from 2 pounds asparagus (30 to 40 stalks; reserve remaining
* stalk portions for another use)*
4 tablespoons (½ stick) unsalted butter
¼ cup unbleached all-purpose flour
2 tablespoons fresh lemon juice
¼ teaspoon freshly ground black pepper
3 egg yolks
½ cup heavy cream

In a strainer under cold running water, thoroughly rinse the morels. In a small saucepan bring 2 cups of the chicken stock to a boil. In a small, heatproof bowl, combine the morels and boiling stock, cover, and let stand, stirring once or twice, until cool.

With a slotted spoon remove the morels from the soaking liquid and reserve. Let the liquid settle for 5 minutes, then pour off and reserve the clear portion; discard the sandy residue. Add additional stock to the soaking liquid to equal 5 cups.

In a 4½- to 5-quart flameproof casserole or Dutch oven, combine the lamb and soaking liquid. Set over medium heat, bring gradually to a brisk simmer, and cook for 10 minutes, skimming to remove any scum that may form. Meanwhile, stick the whole onion with the clove. With kitchen string, tie the leek, celery stalks, bay leaf, and parsley into a bundle.

Add the onion, leek bundle, carrot, and thyme to the casserole. Lower the heat slightly, cover partially, and simmer, stirring occasionally, until the lamb is very tender, about 1¼ hours.

Have ready a large bowl of iced water. Fill a large pan with water and bring it to a boil. Stir in 2 teaspoons of the salt and the asparagus tips and cook, stirring once or twice, until crisp-tender, about 3 minutes. Drain and transfer immediately to the iced water. Cool completely, drain, and pat dry.

Discard the onion, carrot, and leek bundle. Strain the stew, reserving the liquid. Rinse and dry the casserole. Measure the liquid; there should be 3⅓ cups. If not, add water or boil until reduced to the correct quantity. Degrease the liquid and in a medium saucepan bring it to a simmer.

In the casserole over medium heat, melt the butter. When it foams whisk in the flour and cook, stirring constantly, for 4 minutes; do not allow the flour to brown. Whisk in the boiling

liquid. Lower the heat and simmer, stirring, until slightly thickened, about 5 minutes. Stir in the lamb, morels, lemon juice, pepper, and the remaining ½ teaspoon salt.

In a small bowl whisk together the egg yolks and cream until well blended. Gradually whisk in 1 cup of the hot stew liquid. Stir the warmed egg mixture back into the stew. Lower the heat and cook, stirring occasionally, for 5 minutes; do not allow the stew to boil. Stir in the asparagus and cook without boiling until the stew is creamy and thickened, about 5 minutes longer. Adjust the seasoning and serve immediately.

SERVES 6

"*Morels are like the great love of one's life: They don't last.*"

—ROBERT COURTINE

PORCINI

ALSO: CÈPE (FRANCE),
STEINPILZ (GERMANY), PENNY BUN
(ENGLAND), BOROWIKI (POLAND),
KING BOLETE (UNITED STATES),
YAMADORITAKE (JAPAN)

Intensely earthy- and woodsy-tasting (if chanterelles are violins, these are cellos), *Boletus edulis* and the other lesser members of the bolete clan may be the most widely eaten mushrooms on Earth. Certainly they are the most highly regarded.

With large puffy caps (lacking gills on the underside, a defining bolete trait) atop bulbous stems, porcini–"little pigs"–resemble the classic fairy tale (or Disney's *Fantasia*) image of a mushroom. Specimens weighing as much as a pound have been foraged (none are cultivated).

Fresh: Grill or briefly sauté to preserve their meaty texture, or slowly braise to extract deep flavor. Reconstituted dried: Use to flavor sauces, soups, and stews or ragouts of less assertive mushrooms.

Oversized specimens are prone to maggot infestations; those from the northwestern United States are freer from bugs but also more lightly flavored than imports. All spoil quickly and should be cooked or sautéed and frozen within a day or two.

CHIANTI BEEF STEW
with Porcini

A rich and powerful dish, inky with red Tuscan wine, this stew is every bit the opposite of the delicate blanquette of lamb on page 93. Cook the meat to falling-apart tenderness and serve the stew with any earthy starch that suits you—stubby pasta, herbed white beans, creamy polenta, or a mound of mashed potatoes that have been enriched with a dollop of extra-virgin olive oil.

1½ ounces (about 1½ cups) dried porcini
3 cups homemade beef stock or canned beef broth
4 tablespoons olive oil
3 pounds stewing beef, cut into 1-by-2-inch pieces
2 ounce pancetta (unsmoked Italian bacon), finely diced
2 cups finely chopped yellow onions
2 carrots, peeled and finely chopped
2 leeks, white part only, finely chopped
5 garlic cloves, minced
2 bay leaves
3 tablespoons unbleached all-purpose flour
2 tablespoons tomato paste
1 cup dry red wine, preferably Chianti classico
1 teaspoon salt
½ teaspoon freshly ground black pepper
½ cup finely chopped fresh flat-leaf parsley

In a strainer under cold running water, thoroughly rinse the porcini. In a small saucepan bring the beef stock to a boil. In a

small, heatproof bowl, combine the porcini and boiling stock, cover, and let stand, stirring once or twice, until cool.

With a slotted spoon remove the porcini from the soaking liquid and reserve. Let the liquid settle for 5 minutes, then pour off and reserve the clear portion; discard the sandy residue.

Position a rack in the middle of the oven and preheat to 350 degrees F. In a 4½-to 5-quart flameproof casserole or Dutch oven over medium-high heat, warm 2 tablespoons of the olive oil. Pat the meat dry and, working in small batches and adding up to 1 tablespoon additional oil if necessary, brown the meat well on all sides, about 8 minutes per batch. Transfer the browned meat to a bowl; do not clean the casserole.

Add the remaining oil to the casserole and set over medium heat. Add the pancetta and cook, stirring occasionally, until lightly colored, about 7 minutes.

Stir in the onions, carrots, leeks, garlic, and bay leaves. Cover and cook, stirring once or twice and scraping the bottom of the pan, until the vegetables are lightly colored, about 10 minutes.

Sprinkle the flour over the vegetables and cook for 3 minutes, stirring often. Stir in the tomato paste, wine, and the mushroom soaking liquid. Return the meat to the casserole along with any juices from the bowl. Stir in the salt and pepper and bring the stew to a simmer. Cover and bake for 1 hour, stirring once or twice.

Stir in the porcini, return to the oven, and simmer uncovered until the meat is very tender and the stew is thick, about 1 hour longer. Discard the bay leaves and adjust the seasoning. Stir in the parsley and let stand for 1 minute before serving.

SERVES 6

COUNTRY MEAT LOAF
with Mushroom Gravy

Respect-wise, things are definitely looking up for meat loaves. This one, mixed up from three kinds of meat, fragrant with fresh herbs and garlic, and napped with a thick mushroom gravy, is splendid enough for company, and deserves real mashed potatoes, a bottle of good wine (Washington State Pinot Noir is ideal), and maybe even flowers and candlelight.

1 pound fresh cremini
6 tablespoons olive oil
2 cups minced yellow onions
1 large sweet red pepper, finely diced
6 garlic cloves, minced
3 tablespoons minced fresh marjoram, or 1 tablespoon
 dried marjoram, crumbled
1 pound ground beef chuck
1 pound ground veal
1 pound (5 to 6 medium links) Italian-style sweet
 sausage with fennel, removed from the casings
3 eggs, lightly beaten
¾ cup fine dried bread crumbs
3½ cups homemade chicken stock or canned chicken broth
3 teaspoons salt
¾ teaspoon freshly ground black pepper
¼ teaspoon crushed red pepper
1 pound fresh shiitakes, thickly sliced
¼ cup unbleached all-purpose flour

Remove the stems from the cremini. Finely chop the stems; thickly slice the caps.

In a large skillet over low heat, warm 3 tablespoons of the olive oil. Add the onions, sweet pepper, chopped cremini stems, half the garlic, and two thirds of the marjoram. Cover and cook, stirring once or twice, for 10 minutes. Remove from the heat and cool to room temperature.

Position a rack in the middle of the oven and preheat to 350 degrees F.

In a large bowl crumble together the ground chuck, veal, and sausage. Add the onion mixture, the eggs, bread crumbs, ½ cup of the chicken stock, 2 teaspoons of the salt, and the black pepper and mix thoroughly (hands work best). Transfer to a shallow, flameproof baking dish and form into a flat loaf about 2½ inches thick; smooth the top.

Bake the meat loaf until an instant-reading thermometer inserted into the center registers 160 F, about 1 hour and 20 minutes. Remove from the oven and let the meat loaf rest in the pan on a rack for 5 minutes. Transfer carefully to a warmed platter and tent with foil; do not clean the baking dish.

Meanwhile, in a large skillet over medium heat, warm the remaining 3 tablespoons olive oil. Add the remaining garlic, the remaining marjoram, and the crushed red pepper. Cover and cook, stirring once or twice, for 1 minute. Add the sliced cremini and shiitakes and season with the remaining 1 teaspoon salt; cover and cook, tossing and stirring once or twice, until the mushrooms are beginning to render their juices, about 5 minutes. Remove from the heat.

Set the meat loaf baking dish with its drippings over low heat. Whisk in the flour and cook, stirring and scraping the browned

deposits from the pan, for 4 minutes. Remove the baking dish from the heat and slowly whisk in the remaining 3 cups chicken stock. Strain the stock mixture into the skillet with the mushrooms. Set the skillet over medium heat and bring to a simmer. Cook until the gravy has thickened slightly and the mushrooms are tender, about 4 minutes. Adjust the seasoning.

Cut the meat loaf into thick slices and serve hot, accompanied with the gravy.

SERVES 8 TO 10

"The flavour of such mushrooms rises above the main ingredients, like a fine descant which turns a familiar carol into something new, something more enjoyable than one had ever thought possible."

—JANE GRIGSON

RABBIT BRAISED WITH MUSHROOMS, ROOT VEGETABLES, AND BACON

Fresh rabbits, once common, then less so, are now available in better butcher shops. These raised-for-food rabbits are not gamey-tasting, but instead resemble barnyard (free-range in the modern parlance) chickens—richly flavored and slightly resistant to the tooth, delectable. A mixture of dried mushrooms will provide the most flavor, texture, and visual appeal, but using only a single variety will also yield good eating.

1½ ounces (about 1½ cups) mixed dried mushrooms,
 such as porcini, morels, and chanterelles
3 cups homemade chicken stock or canned chicken broth
1 cup medium-dry white wine
6 ounces slab bacon, trimmed and cut into ¼-inch dice
3 tablespoons olive oil
2 fresh rabbits (about 6 pounds total) each cut into
 6 to 8 serving pieces
1 cup chopped yellow onions
2 bay leaves
3 tablespoons unbleached all-purpose flour
1 teaspoon salt
1½ cups diced, peeled carrots
1 cup diced, peeled celery root
½ cup diced, peeled parsnips
Freshly ground black pepper

In a strainer under cold running water, thoroughly rinse the mushrooms. In a medium saucepan combine the chicken stock and wine and bring to a boil. In a medium, heatproof bowl, combine the mushrooms and boiling stock, cover and let stand, stirring once or twice, until cool.

With a slotted spoon remove the mushrooms from the soaking liquid and reserve. Let the liquid settle for 5 minutes, then pour off and reserve the clear portion; discard the sandy residue.

Set a large, deep skillet (about 5-quart capacity) over medium heat. Add the bacon and 1 tablespoon of the olive oil and cook, stirring occasionally, until the bacon is just crisp, about 10 minutes. With a slotted spoon transfer the bacon to paper towels to drain; do not clean the skillet.

Set the skillet over medium heat. Pat the rabbit pieces dry. When the rendered bacon fat is hot, add the rabbit, working in 2 batches to avoid crowding the pan, and cook uncovered, turning once or twice, until lightly browned, about 5 minutes per side. Transfer the browned rabbit to a bowl and reserve. Do not clean the skillet.

Set the skillet over low heat. Add the onions and bay leaves, cover, and cook, stirring occasionally and scraping the bottom of the pan, for 10 minutes. Whisk in the flour and cook without browning for 1 minute. Whisk in the mushroom soaking liquid. Stir in the salt.

Return the rabbit, along with any juices from the bowl, to the skillet. Raise the heat and bring to a simmer. Cover and cook, turning and rearranging the rabbit pieces once or twice, for 20 minutes. Add the mushrooms, re-cover, and cook until the rabbit is just tender, another 30 minutes. Transfer the rabbit to a bowl.

Meanwhile, in a large skillet over medium heat, warm the remaining 2 tablespoons olive oil. Add the carrots, celery root, and parsnips and cook uncovered, tossing and stirring, until lightly browned, about 10 minutes. Stir the browned vegetables and bacon into the rabbit sauce and simmer uncovered, stirring once or twice, for 15 minutes. The sauce will thicken slightly and the vegetables should be just tender.

Return the rabbit to the pan and cook, basting often, and turning once or twice, until just heated through, about 5 minutes. Remove and discard the bay leaves, season to taste with pepper, and serve hot.

SERVES 6

QUICK PORK STROGANOFF

Pork tenderloins, which are often sold sealed into plastic wrappers, come and go in the market. Buy them when you see them and store them in the freezer. The meat, lean and tender, cooks up quickly in dishes like this creamy pork and mushroom ragout. Serve it with white rice, mashed potatoes, or buttered noodles.

2 small pork tenderloins (about 1½ pounds total),
 trimmed and cut into ½-inch cubes
2 tablespoons vegetable oil
¾ cup homemade chicken stock or canned chicken broth
¼ cup dry white wine
2 tablespoons unsalted butter
¼ cup minced shallots
¾ pound fresh cremini, quartered
¾ teaspoon salt
¾ cup crème fraîche or heavy cream
Drops of fresh lemon juice
Freshly ground black pepper

Pat the cubed pork dry. In a large skillet over medium heat, warm the oil. Add the pork and cook uncovered, stirring once or twice, for 10 minutes. The pork will render some liquid, which will evaporate, leaving the pork to brown lightly. Stir in the stock and wine, cover partially, and simmer, stirring once or twice, until the pork is just tender and the liquid has reduced by half, about 10 minutes.

Meanwhile, in a large skillet over low heat, melt the butter. Add the shallots, cover, and cook, stirring once or twice, for 3 minutes; do not brown. Stir in the mushrooms and ½ teaspoon of the salt, raise the heat to medium, re-cover, and cook, stirring once or twice, until the mushrooms render their juices, about 5 minutes.

Add the mushroom mixture and the crème fraîche to the skillet with the pork, bring to a simmer, and cook uncovered, stirring once or twice, until the pork is very tender and the sauce has reduced by half, about 5 minutes. Season to taste with the remaining ¼ teaspoon salt, the lemon juice, and pepper; serve hot.

SERVES 4

"[Morels'] brief emergence coincides with the season

of rebirth and beauty, when Nature springs awake with

a sweeping mandate for all her subjects to breed. Seeking morels

during this time puts lead in your pencil."

—JOHN RATZLOFF

MOSTLY MEATLESS

TRUFFLED VEGETABLE POT PIES

CHEESE-AND-MUSHROOM STRATA
with Fresh Tomato Sauce

RICH SCRAMBLED EGGS
with White Truffles

POACHED EGGS
in Dijon Mushroom Sauce

CREAMY MUSHROOM AND POTATO GRATIN

MOREL AND HAZELNUT DRESSING

BAKED MUSHROOM, WHEAT BERRY,
AND BROWN RICE PILAF

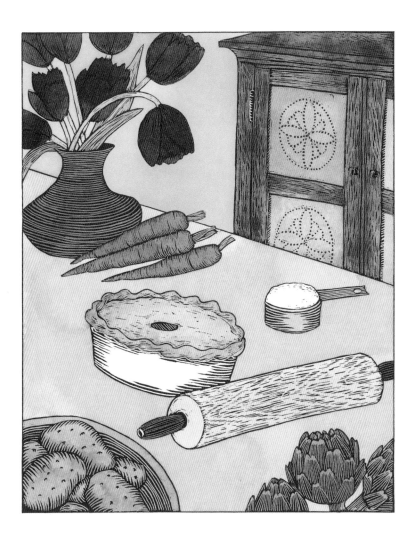

TRUFFLED VEGETABLE POT PIES

If pot pies are something you normally buy frozen at the supermarket and heat up to eat while reading a murder mystery, you have a surprise in store. These pot pies are rich and elegant, thanks to the ineffable presence of black truffles, and make the perfect light but sophisticated main course for a brunch or supper. Diced cooked chicken meat can replace some of the vegetables if determined carnivores are on the guest list.

4 large artichokes
3 cups homemade chicken stock or canned chicken broth
1 cup dry white wine
1 pound (3 medium) boiling potatoes, diced
3 carrots, peeled and diced
2 tablespoons unsalted butter
2 large leeks, white part only, chopped
3 tablespoons unbleached all-purpose flour, plus additional
 flour for the work surface
½ cup heavy cream
1 package (10 ounces) frozen peas, thawed and drained
1 fresh black truffle (about 1 ounce), peeled if necessary and minced
Pastry Dough, chilled (recipe follows)
1 egg, well beaten

Fill a very large pot three-fourths full with water and bring it to a boil over high heat. Trim off the stem ends of the artichokes. Add them to the boiling water and cook uncovered, stirring once or twice, until the tip of a knife easily pierces a stem at its thickest

BLACK TRUFFLE

Rare (overharvesting and pollution have reduced the yield), expensive ($1,000-plus per pound, with a one-inch truffle weighing about an ounce), and ecstatically regarded. Veined, bumpily black-gray, and slightly warty, with a brittle, waxy texture and a flavor of earth, vanilla, or violets.

Black truffles are found in much of Europe, as well as the United States and parts of Africa, but the finest specimens come from Périgord, in France, and grow in symbiosis with oak trees. Once thought to appear where lightning struck; foraged by hunters with pigs or dogs trained to sniff them in the earth near the trees' roots. The season for Périgord truffles is mid-November to March.

Store: Keep dry in a tightly covered container in the refrigerator for up to two weeks (from harvest, not purchase). Raw eggs stored in the same container will absorb truffle flavor through their shells and are delicious scrambled or poached. Truffles coated with a layer of dirt last longer; remove it with a stiff brush, then peel (use the trimmings in stocks) and thinly slice or mince the truffle just before use. Grand preparations may include whole braised truffles, but slicing or mincing distributes the flavor further and the briefest possible cooking preserves it.

Truffles defy perfect preservation; those jarred in minimal water are barely acceptable substitutes. Attempts to cultivate black truffles have not produced good results.

point, about 25 minutes. Drain well and cool completely. Pull away and discard the artichoke leaves (or have them for lunch); scoop out and discard the chokes and dice the hearts.

In a medium sauce pan over high heat, combine the chicken stock and wine and bring to a boil. Add the potatoes and carrots, lower the heat, and simmer uncovered, stirring occasionally, until just tender, about 20 minutes. Drain, reserving the stock (there should be about 2¼ cups); set the potatoes and carrots and the stock aside separately.

In a medium saucepan over moderate heat, melt the butter. When it foams add the leeks, cover, and cook, stirring once or twice, until tender, about 8 minutes. Stir in the 3 tablespoons flour and cook, stirring often, for 2 minutes. Gradually whisk in the reserved stock and the heavy cream. Bring to a simmer and cook uncovered, stirring occasionally, until reduced slightly and thickened, about 15 minutes. Remove from the heat, adjust the seasoning, and cool to room temperature.

In a medium bowl combine the potatoes and carrots, artichoke hearts, peas, truffle, and cooled sauce. The filling can be prepared to this point several hours in advance. Divide among four 2½-cup ovenproof casseroles. Cover and refrigerate; return to room temperature before proceeding.

Position a rack in the middle of the oven and preheat to 400 degrees F. Lightly flour the work surface. Unwrap the dough, lightly flour it, and roll it out about ⅓ inch thick. Using a glass or bowl as a guide, with a sharp knife cut out 4 rounds of dough about 1 inch smaller in diameter than the casseroles. Flute the edges of each round with the tines of a fork. With a long spatula, transfer the rounds to the casseroles (some filling will remain visible around the edges).

Set the casseroles on a baking sheet. Brush the dough rounds lightly with the beaten egg. Bake the pot pies until the crusts are golden and the filling is bubbling, about 25 minutes. Remove from the oven and let stand on a rack for 5 minutes before serving; serve hot.

SERVES 4

PASTRY DOUGH

1¾ cups unbleached all-purpose flour, plus additional
 flour for the work surface
¼ teaspoon salt
3 tablespoons unsalted butter, well chilled, cut into small pieces
¼ cup solid vegetable shortening, well chilled, cut into small pieces
3 to 4 tablespoons iced water

In a food processor or in a medium bowl, combine the 1¾ cups flour and the salt. In the food processor using short bursts of power, or in a bowl using a pastry cutter, blend the butter and shortening into the flour until the mixture just resembles coarse meal; do not overwork. Mix in enough iced water, 1 tablespoon at a time, to form a soft dough.

Sprinkle the work surface lightly with flour. Turn out the dough onto the floured surface. Gather it into a ball, flatten it into a disk, and wrap tightly in plastic wrap. Refrigerate for at least 1 hour. The dough can be prepared up to 1 day in advance.

MAKES ENOUGH DOUGH TO TOP FOUR 2½-CUP POT PIES

CHEESE-AND-MUSHROOM STRATA
with Fresh Tomato Sauce

A *strata* is a kind of savory bread pudding, bound by an eggy custard and often including cheese. It makes a fine main course for lunch or brunch, especially when accompanied with a fresh tomato sauce as given here, but it can also serve as a rich and hearty side dish, sans sauce, alongside plain roasted chicken or another simple (no cheese, no eggs) main course.

3 tablespoons olive oil
1 pound fresh cremini, quartered
1 pound fresh shiitakes, quartered
2 teaspoons salt
½ teaspoon freshly ground black pepper
Unsalted butter for the baking dish
6 eggs
2 cups half-and-half
¼ cup pesto sauce, commercially prepared or homemade
2 teaspoons hot-pepper sauce
8 slices (½ inch thick) from a 5-by-9-inch loaf of firm white
 sandwich bread, day old but not dry, tough crusts trimmed
2 cups (½ pound) grated Bel Paese or other semimoist,
 mild white melting cheese
Fresh Tomato Sauce, heated to simmering (recipe follows)

In a large skillet over medium heat, warm the olive oil. Add the mushrooms and season with ¾ teaspoon of the salt and the pepper; cover and cook, stirring once or twice, until the mushrooms

render their juices, about 6 minutes. Uncover the skillet, raise the heat, and cook, tossing and stirring often, until the mushrooms are lightly browned and their juices have evaporated, 3 to 4 minutes. Remove from the heat and cool to room temperature.

Butter a 10-by-13-inch oval gratin dish. In a large bowl whisk the eggs. Whisk in the half-and-half, pesto, hot-pepper sauce, and the remaining 1¼ teaspoons salt. Arrange 4 slices of the bread in a single layer in the prepared dish. Spoon half of the mushrooms evenly over the bread. Ladle half of the egg mixture evenly over the mushrooms. Sprinkle evenly with half of the cheese. Repeat with the remaining ingredients, ending with a cheese layer. Cover the dish and let stand at room temperature for 1 hour.

Position a rack in the middle of the oven and preheat to 350 degrees F. Uncover the strata and bake until it is puffed and firm and the top has browned, about 40 minutes. Remove from the oven and let rest in the dish on a rack for 5 minutes. Serve, accompanied with the tomato sauce.

SERVES 6 AS A MAIN COURSE, 8 AS A SIDE DISH

FRESH TOMATO SAUCE

3 ¼ pounds fresh Italian (plum) tomatoes
3 tablespoons olive oil
¾ cup finely chopped yellow onions
3 garlic cloves, minced
1 ¾ teaspoons salt
¾ teaspoon freshly ground black pepper

Core and chop the tomatoes. There should be 8 cups combined chopped tomato and juice.

In a wide, deep pan over low heat, warm the olive oil. Add the onions, cover, and cook, stirring often, until tender and lightly colored, about 15 minutes. Stir in the garlic and cook uncovered, stirring often, for 3 minutes.

Stir in the tomatoes, salt, and pepper and bring to a simmer. Cover and cook, stirring occasionally, until the tomatoes are tender and very juicy, about 10 minutes. Uncover, raise the heat slightly and cook, stirring often, until the sauce has reduced by half, about 15 minutes.

Cool slightly, then force the sauce through the medium blade of a food mill or purée in a food processor. Adjust the seasoning. The sauce can be prepared up to 3 days ahead and refrigerated, or up to 1 month ahead and frozen.

MAKES ABOUT 4 CUPS

WHITE TRUFFLE

G narled but less warty than black truffles, veined, pale yellow to tan with ivory interiors, brittle texture. Foraged near trees with canine assistance, primarily in the Italian region of Piedmont, especially near the city of Alba. A one-inch truffle will weigh about one ounce. Prices are similar (fantastic) to those of black truffles; demand is up (Italian food is "in") and supplies are down.

Season: Late September to late January, peaking in November. Flavor: Experts detect garlic, sex, and cheese, veiled behind mushrooms and earth; all agree the effect is remarkable and unique.

Store: Keep dry in an airtight container in the refrigerator for up to two weeks from estimated time of harvest. (Buried in dry Arborio rice in a covered container for a few days, the truffles pass on considerable flavor to the rice, which is then delicious—with or without the addition of the truffles themselves—in risotti.) Brush off dirt but do not

"Truffles make women more tender and men more agreeable."

—BRILLAT-SAVARIN

peel. Shave into paper-thin slices over hot, simple foods (risotto, pasta, melted Fontina cheese, eggs) just before serving.

Delicious white truffle paste is available in tubes; jarred white truffles preserved in minimal water have decent texture but considerable reduction of flavor.

RICH SCRAMBLED EGGS
with White Truffles

The eggs in this dish (as with almost anything else that gets topped with white truffles) are a neutral vehicle for the potent fungi, their heat releasing the truffle's flavor and their own flavor subservient to the remarkable effect created by the other. The price of white truffles is approximately equal to their (rumored) power as an aphrodisiac, both good reasons to serve this as the first course of a light but opulent and intimate feast for two.

6 very fresh eggs, preferably from free-range chickens
Pinch of salt
2 tablespoons unsalted butter
¼ cup crème fraîche, at room temperature, whisked
 until smooth and liquid
1 small (about 1 ounce) fresh white truffle

In a medium bowl briefly whisk the eggs. Whisk in the salt.

In a medium skillet over moderate heat, melt the butter. When it foams add the eggs. Cook, stirring constantly, until the eggs are softly but evenly set, about 1½ minutes.

Divide the eggs between two warmed plates. Drizzle the crème fraîche evenly around the eggs. Shave the truffle in paper-thin slices evenly over the eggs (use a truffle slicer or a swivel-bladed vegetable peeler), covering them completely and using all of the truffle. Serve immediately.

SERVES 2

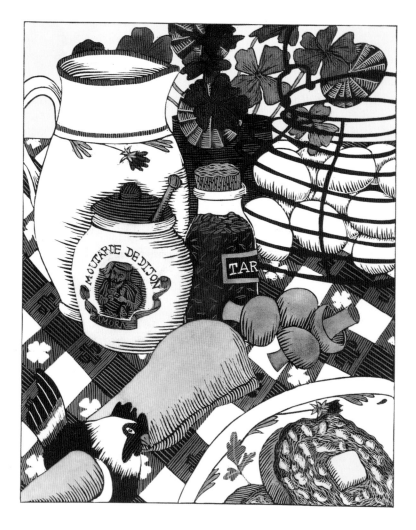

POACHED EGGS
in Dijon Mushroom Sauce

Mushrooms, tarragon, and mustard are a remarkably compatible trio of ingredients, making this brunch, lunch, or light supper dish deliciously successful. The eggs are served atop toasted English muffin halves and accompanied, if you wish, with pan-sizzled ham steaks.

4 tablespoons (½ stick) unsalted butter
¼ cup sliced green onions, green tops included
1 teaspoon dried tarragon, crumbled
¾ pound fresh cremini, sliced
3 teaspoons salt
½ teaspoon freshly ground black pepper
¾ cup homemade chicken stock or canned chicken broth
½ cup heavy cream
2 teaspoons Dijon-style mustard
2 teaspoons unbleached all-purpose flour
1 tablespoon white wine vinegar
8 fresh, large eggs
4 English muffins, split and toasted

In a medium skillet over low heat, melt 3 tablespoons of the butter. Add the onions and tarragon and cook uncovered, stirring often, for 2 minutes. Add the mushrooms, season with 1 teaspoon of the salt and the pepper, and cook uncovered, tossing and stirring, for 3 minutes. Stir in the chicken stock and cream, bring to a simmer, and cook until the mushrooms are almost

tender and the sauce has reduced slightly, about 4 minutes. Whisk the mustard into the sauce.

In a small bowl mash together the remaining 1 tablespoon butter and the flour. Whisk this paste, bit by bit, into the simmering sauce. Cook for 1 minute and adjust the seasoning.

Meanwhile, fill a large, deep skillet about three-fourths full of water and bring to a simmer. Stir in the vinegar and the remaining 2 teaspoons salt. One at a time, crack the eggs into a small bowl, then slip the eggs into the water. Regulate the temperature to remain just below an active simmer. With a slotted spoon gently gather and shape the egg whites around their yolks into approximate ovals. Cook about 4 minutes (for a fairly soft yolk), or until done to your liking.

Reheat the mushroom sauce if necessary. Set 2 English muffin halves, toasted sides up, on each of 4 plates. With a slotted spoon remove the eggs from the water, press the bottom of the spoon onto a folded kitchen towel to absorb all moisture, and transfer the eggs to the muffins. Spoon the sauce evenly over the eggs, using it all; serve immediately.

SERVES 4

CREAMY MUSHROOM
AND POTATO GRATIN

The gratin is subtly seasoned, letting the mingled tastes of mushrooms and potatoes dominate, making it a perfect partner to unsauced roast chicken, turkey, veal, pork, or fish. The dish, however, is flexible and in other menus the gratin will accommodate modest amounts of fresh herbs (particularly thyme), garlic, sautéed onions, or grated cheese.

6 tablespoons (¾ stick) unsalted butter, plus unsalted
* butter for the baking dish*
1 pound fresh shiitakes, sliced
1 pound fresh oyster mushrooms, sliced
2 teaspoons salt
3 pounds russet (baking) potatoes, peeled and thinly sliced
¾ teaspoon freshly ground black pepper
1½ cups homemade chicken stock or canned chicken broth
1 cup crème fraîche or heavy cream

Position a rack in the middle of the oven and preheat to 375 degrees F. Butter a shallow (2½-inch sides) 3-quart casserole.

In a large skillet over medium heat, melt 4 tablespoons of the butter. When the butter foams add the mushrooms and 1 teaspoon of the salt and cook, tossing and stirring, until the mushrooms begin to render their juices, about 5 minutes. Remove from the heat and cool to room temperature.

In a large bowl toss together the mushrooms, their juices, the potatoes, the remaining 1 teaspoon salt, and the pepper. Transfer

to the prepared baking dish and spread evenly. In a bowl whisk together the chicken stock and crème fraîche; pour the mixture evenly over the contents of the casserole. Cut the remaining 2 tablespoons butter into small pieces and scatter over the top of the casserole.

Bake, tilting the dish occasionally to distribute the juices evenly, until the potatoes are tender and the top is crusty and brown, about 1¼ hours. Remove from the oven and let the casserole stand on a rack for 5 minutes before serving.

SERVES 8

OYSTER
MUSHROOM

ALSO: TREE OYSTER, PLEUROTTE
(FRANCE), SHIMEJI (JAPAN)

S oftly lobed, taupe to ivory, oysters grow in overlapping tonguelike clusters near beech or poplar trees in the wild, or are cultivated on sterilized straw. They are among the most successful of farmed exotics and are widely available fresh; sometimes found dried.

Flavor: Delicate, even elusive, and mildly mushroomy. Texture: Quickly cook down into a soft mass. Foraged oysters, in season in spring and early summer in the northern United States and Europe, are more emphatically flavored.

Best in soups and sauces or where an enriched background flavor—but not a physical presence—is desired. Dried: Even more subtle than fresh; reconstitute and use similarly.

Very perishable, oyster mushrooms should be consumed within a day or two of purchase. Blue, pink, and yellow oysters lose their unique color when cooked, fading to gray.

Also look for white trumpets or angel trumpets, equally mild-flavored oyster cousins (no relation to the trompettes de la mort, page 84).

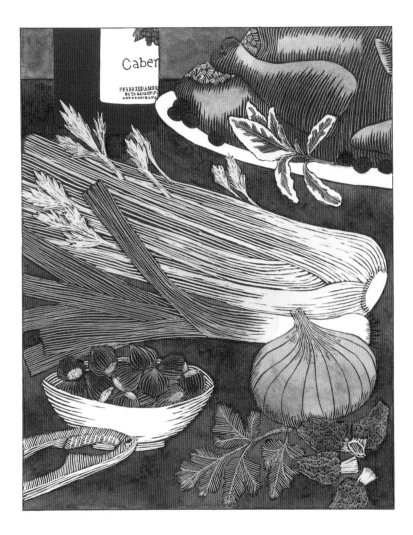

MOREL & HAZELNUT DRESSING

In spring this dressing can be prepared using intensely flavored foraged morels for serving alongside a glazed Easter ham or roast leg of lamb. At Thanksgiving time, milder cultivated morels will be the only choice, an investment worth making, since the dressing is delicious accompanying a handsomely browned turkey. Baked separately in a heavy dish, the dressing acquires a crisp, golden crust, which I like, but it can also be cooked inside the turkey if you prefer.

Unsalted butter for the baking dish, plus 6 tablespoons (¾ stick)
 unsalted butter
1 cup (about 5 ounces) natural raw hazelnuts
 (unblanched), coarsely chopped
1 cup chopped yellow onions
1 cup chopped leeks, white part only
1 cup chopped celery
1 teaspoon dried thyme, crumbled
¾ pound fresh morels
1¾ teaspoons salt
2 cups homemade chicken stock or canned chicken broth
¼ cup Frangelico or other hazelnut liqueur
10 cups crustless white-bread cubes, from a 2-pound
 day-old (but not dry) loaf
3 eggs, well beaten
½ cup finely chopped fresh flat-leaf parsley
1 teaspoon freshly ground black pepper

Position a rack in the middle of the oven and preheat to 350 degrees F. Butter a shallow 3½-quart baking dish with a cover.

In a medium skillet over moderate heat, melt 3 tablespoons of the butter. When the butter foams add the hazelnuts and cook, stirring once or twice, until fragrant and lightly browned, about 5 minutes. Remove from the heat and reserve the nuts and their butter.

In a large skillet over low heat, melt the remaining 3 tablespoons butter. Add the onions, leeks, celery, and thyme; cover and cook, stirring once or twice, for 10 minutes. Add the morels, sprinkle with the salt, raise the heat to medium, and cook, tossing and stirring, until the morels soften slightly, about 4 minutes. Add the stock and Frangelico, bring to a simmer, and cook uncovered, stirring once or twice, for 5 minutes. Cool slightly.

In a very large bowl, thoroughly mix together the bread cubes, mushroom mixture, the hazelnuts and their butter, eggs, parsley, and pepper. Spoon the dressing into the prepared dish, cover, and bake 30 minutes. Uncover and bake until the dressing is lightly browned, 15 to 20 minutes longer. Serve hot.

MAKES ABOUT 12 CUPS; SERVES 8

BAKED MUSHROOM, WHEAT BERRY, AND BROWN RICE PILAF

Nutty, crunchy, and satisfying, with the deep, rich flavor of mixed mushrooms and aromatic vegetables, this grain dish is good alongside roast chicken, turkey, or pork, and can even stand alone, as the main course of an informal meatless lunch or supper.

1 cup wheat berries
¾ ounce (about ¾ cup) dried porcini
About 5 cups homemade chicken stock or canned chicken broth
4 tablespoons (½ stick) unsalted butter
1 large leek, white part only, chopped
½ cup chopped yellow onions
2 carrots, peeled and chopped
1 bay leaf
1 cup brown rice
¾ teaspoon salt
½ teaspoon freshly ground black pepper
½ pound fresh cremini, sliced
½ pound fresh shiitakes, sliced
1 tablespoon minced fresh thyme

In a bowl soak the wheat berries in cold water to cover generously for 24 hours.

In a strainer under cold running water, thoroughly rinse the porcini. In a small saucepan bring 2 cups of the chicken stock to a boil. In a small, heatproof bowl, combine the porcini and boil-

ing stock, cover, and let stand, stirring once or twice, until cool.

With a slotted spoon remove the porcini from the soaking liquid and coarsely chop them. Let the liquid settle for 5 minutes, then pour off and reserve the clear portion; discard the sandy residue. Add enough of the remaining chicken stock to the mushroom liquid to equal 4½ cups.

Position a rack in the middle of the oven and preheat to 350 degrees F. In a flameproof 2½-quart casserole or Dutch oven over low heat, melt 2 tablespoons of the butter. Add the leek, onions, carrots, and bay leaf; cover and cook, stirring once or twice, for 10 minutes. Drain the wheat berries and add them, the brown rice, and the mushroom liquid mixture to the casserole. Stir in ½ teaspoon of the salt and the pepper and bring to a simmer. Cover, place in the oven, and bake for 35 minutes.

Meanwhile, in a medium skillet over moderate heat, melt the remaining 2 tablespoons butter. When the butter foams add the cremini, shiitakes, and the remaining ¼ teaspoon salt. Cover and cook, stirring once or twice, until the mushrooms just begin to render their juices, about 4 minutes.

Stir the sautéed mushrooms and their juices, the porcini, and thyme into the pilaf, re-cover, and bake another 20 minutes. Uncover the casserole and bake until almost all of the liquid has been absorbed by the grains, 10 to 15 minutes more. Remove from the oven, cover the casserole, and let stand for 1 minute. Fluff the pilaf with a fork, discard the bay leaf, and serve hot.

Serves 4 to 6 as a main course, 6 to 8 as a side dish

The following suppliers of cultivated exotic and wild mushrooms and other mushroom paraphernalia are highly recommended.

American Spoon Foods
P.O. Box 566
Petoskey, Michigan 49770
800/222-5886
Fresh and dried Michigan morels

Aux Delices Des Bois, Inc.
4 Leonard Street
New York, New York 10013
212/334-1230
Fresh and dried exotic and wild mushrooms

Dean and DeLuca
560 Broadway
New York, New York 10012
800/221-7714; 212/431-1691
Fresh and dried exotic and wild mushrooms

Delftree Farm
P.O. Box 460
Pownal, Vermont 05261
800/243-3742
Premium certified fresh organic shiitakes

Earthy Delights
618 Seymour Street
Lansing, Michigan 48933
800/367-4709
Fresh and dried exotic and wild mushrooms

Fresh & Wild
P.O. Box 2981
Vancouver, Washington 98668
206/737-3652
Fresh exotic and wild mushrooms

Fungi Perfecti
P.O. Box 7634
Olympia, Washington 98507
206/426-9292
Certified organic mushroom growing kits and supplies

Hans Johannsson, Inc.
44 West 74th Street
New York, New York 10023
212/787-6496
Fresh and dried exotic and wild mushrooms

Sohn's Forest Mushrooms
610 South Main Street
Westfield, Wisconsin 53964
608/296-2456
Mushroom growing kits and supplies

RECOMMENDED READING

For technical information on gathering and handling wild mushrooms, for mushroom appreciation in general, or for a wealth of mushroom recipes, these books are variously and highly recommended.

Arora, David. *Mushrooms Demystified.* Berkeley: Ten Speed Press, 1979, 1986.

Carluccio, Antonio. *A Passion for Mushrooms.* Topsfield, Massachusetts: Salem House, 1989.

Czarnecki, Jack. *Joe's Book of Mushroom Cookery.* New York: Atheneum, 1988.

Grigson, Jane. *The Mushroom Feast.* New York: Lyons & Burford, 1975.

Phillips, Roger. *Mushrooms of North America.* Boston: Little, Brown, 1991.

Ratzloff, John. *The Morel Mushroom.* Stillwater, Minnesota: Voyageur Press, 1990.

Schneider, Elizabeth. *Uncommon Fruits & Vegetables.* New York: Harper & Row, 1986.

INDEX

TABLE OF EQUIVALENTS

The exact equivalents in the following tables have been rounded for convenience.

US/UK
oz=ounce
lb=pound
in=inch
ft=foot
tbl=tablespoon
fl oz=fluid ounce
qt=quart

Metric
g=gram
kg=kilogram
mm=millimeter
cm=centimeter
ml=milliliter
l=liter

Weights

US/UK	Metric
1 oz	30 g
2 oz	60 g
3 oz	90 g
4 oz (¼ lb)	125 g
5 oz (⅓ lb)	155 g
6 oz	185 g
7 oz	220 g
8 oz (½ lb)	250 g
10 oz	315 g
12 oz (¾ lb)	375 g
14 oz	440 g
16 oz (1 lb)	500 g
1½ lb	750 g
2 lb	1 kg
3 lb	1.5 kg

Oven Temperatures

Fahrenheit	Celsius	Gas
250	120	½
275	140	1
300	150	2
325	160	3
350	180	4
375	190	5
400	200	6
425	220	7
450	230	8
475	240	9
500	260	10

Liquids

US	Metric	UK
2 tbl	30 ml	1 fl oz
¼ cup	60 ml	2 fl oz
⅓ cup	80 ml	3 fl oz
½ cup	125 ml	4 fl oz
⅔ cup	160 ml	5 fl oz
¾ cup	180 ml	6 fl oz
1 cup	250 ml	8 fl oz
1½ cups	375 ml	12 fl oz
2 cups	500 ml	16 fl oz
4 cups/1 qt	1 l	32 fl oz

Length Measures

⅛ in	3 mm
¼ in	6 mm
½ in	12 mm
1 in	2.5 cm
2 in	5 cm
3 in	7.5 cm
4 in	10 cm
5 in	13 cm
6 in	15 cm
7 in	18 cm
8 in	20 cm
9 in	23 cm
10 in	25 cm
11 in	28 cm
12 in / 1 ft	30 cm